Contents

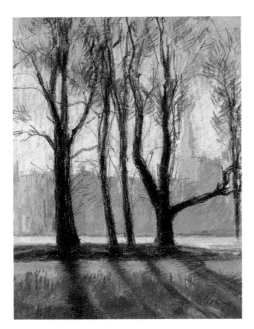

Introduction 4

MATERIALS 6
TECHNIQUES 14
COLOUR AND TONE 22
LANDSCAPE 30
SKIES 36
TREES AND FOLIAGE 40
WATER 46
BUILDINGS 50
PORTRAITS 58
THE FIGURE 66
STILL LIFE 74
INTERIORS 82

Conclusion 92
List of Suppliers 94
Index 95

INTRODUCTION

Pastel painting is certainly intriguing. But, more than that, it is captivating, challenging and, ultimately, highly rewarding. In essence it is an uncomplicated medium which allows for the most direct path from a person's feelings to a finished picture. As children, we probably all began our journey into art using a few basic coloured chalks because an effect can be achieved immediately. Yet the beauty of pastels is that they can be used to produce more ambitious works.

One only has to look at the work of accomplished pastellists such as Edgar Degas (1834–1917) and the advanced techniques he used in his pastels of ballet dancers, or the American Impressionist Mary Cassatt (1844–1926), to see that anything is possible. Today the art is thriving and pastel is more widely used than at any other time in its history. A trip around the annual exhibition of any national Pastel Society, such as that at the Mall Galleries in London, will prove that the very greatest variety of subjects and treatments are possible with this medium.

To get the very best out of any medium, it obviously makes sense to explore what that medium does best, particularly in relation to one's own ideas and objectives. For me, as a painter as well as a regular user of pastels, the excitement in producing the work for this book came from discovering new approaches and focuses in my usual subject matter by developing the same ideas I have explored in oils with pastels. I hope this journey of exploration will offer encouragement and direction, and highlight the range of possibilities and effects, from the subtle to the dazzling, that can be achieved with this wonderfully engaging medium.

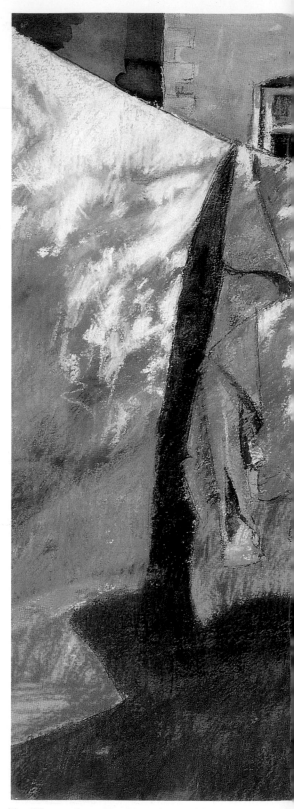

THE WASHING LINE, 51 x 66 cm (20 x 26 in)

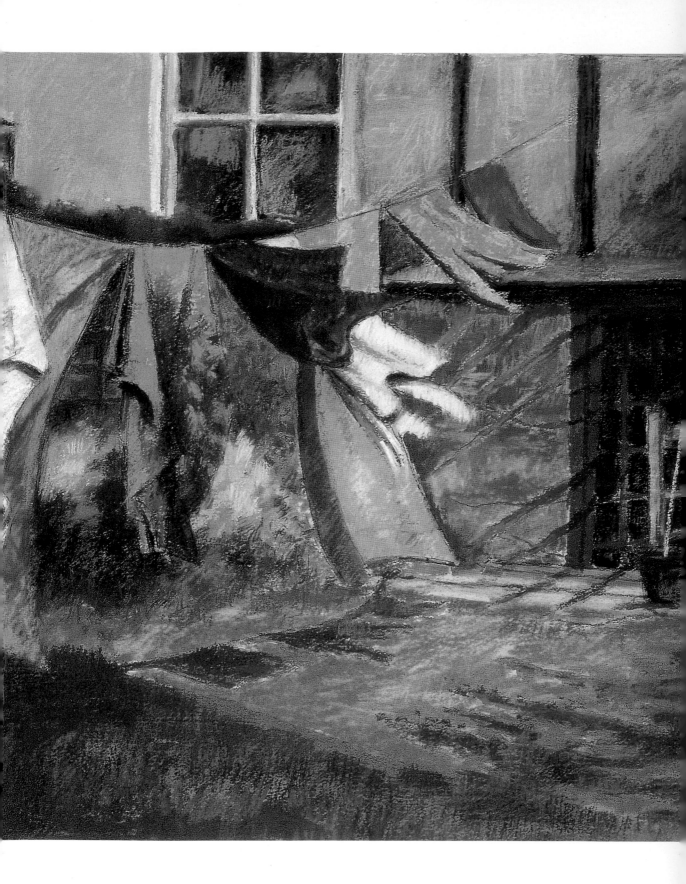

Materials

Pastels, set out in a box – a range of beguiling colours and tints – beg you to try them out. And when you do, you will find the ability to create is immediate. But first of all you will need to choose those pastels. The range available is vast, not only colours and tints, but types of pastels, brands, and sizes. In this chapter we will introduce you to the medium and its foibles, and guide you in selecting a first affordable range of colours.

PASTELS

A pastel stick is made up from pigment held together with what is called a binder. Just as with oil paints, where the pigment is suspended in linseed or poppy oil, and watercolour, where the binder is gum arabic, so pastels are usually bound together with gum tragacanth. In addition to the basic pigment, clay and chalk are sometimes added to lighten and extend the colour. Generally speaking, there is a wider range of tints, or shades, available in the lighter colours and such colours also tend to be much softer and more prone to crumbling.

Hard and soft pastels
Most of the pastels available at present tend to fall into either the hard or soft category and this is usually relative to whether they are light or dark colours. Darker colours need more binder and therefore tend to be harder. But pastels will vary in texture between brands. Hard pastels – across the whole tonal range, from light to dark – are called chalks but it can be difficult to distinguish between chalks and pastels. In terms of working, it makes no difference at all and in fact most pastellists keep a variety of hard, soft and chalk-type pastels. Conté sticks are a type of chalk and are useful in brown and black for sketching, underdrawings, tonal work and for fine, linear, finishing touches.

Pastel pencils
Pastel pencils come in a wide range of colours and are particularly useful for fine details. They do not have the same texture as stick pastels but, because they can be sharpened to a point, they can add a precise highlight, or reestablish outlines, in the final stages of a pastel painting.

Oil pastels
Although oil pastels resemble chalk pastels, they are quite a different medium. Whereas chalk pastels will mix with water, oil pastels will only stand dilution with white spirit or oil. Although it could not be categorically said that oil and chalk pastels should never be used together, the fundamental difference in their composition and application means that most artists prefer to use each medium separately.

BASIC PALETTE

Pastel manufacturers produce a huge range of colours. This is to compensate for the fact that, unlike paint of any kind, you cannot mix pastels prior to using them, or not easily. With three tubes of paint it is possible to mix an almost infinite number

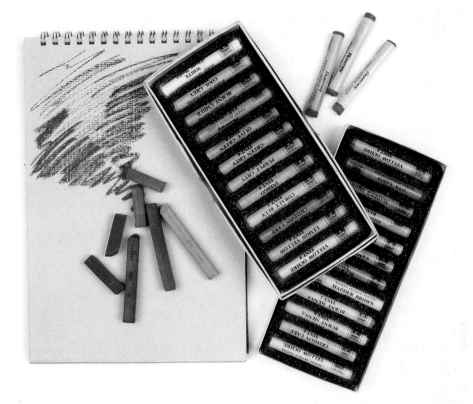

Manufacturers' boxed sets of pastels provide a good selection to start with: for landscapes (Rowney), centre, and portraits (Rowney), right. Left, harder chalks have sharp edges which are useful for details.

of colours, all with subtle differences. Three sticks of pastel, however, would not get you very far at all. So, although the range of pigments is similar, they are available in a wide range of tints. If you take one colour – burnt umber, for example – you will find it available in around six tints. This ranges from the darkest, rich brown, which is how you would expect that colour to look straight from a tube, to the lightest, pale pinky-brown, almost cream, which is achieved by adding white to the basic pigment. In effect, the gradation of colours is being made for you by the manufacturer so you do not have to mix up all the different shades for yourself.

Selecting your colours

The implication so far has been that you will need hundreds of sticks of pastel before being able to contemplate starting work. This, you will be pleased to hear, is not the case and marvellous results are possible with relatively few colours. Working with a limited palette is standard practice in any medium in order to learn about basic colour harmonies. Moreover, experienced pastellists often deliberately use a restricted palette, not for financial reasons but because a smaller range can concentrate the mind and application quite profoundly, usually with better results.

So start with a few colours and tints, experiment with them and see how they behave and what colour harmonies are possible, before adding to your collection. Throughout this book, there are lists of the palette of pastels used for each exercise and demonstration. These are a useful guide and will show you how the subject matter will affect your choice.

Primary colours

Be sure that you include in your basic palette at least one each of the primary colours – red, blue and yellow – which cannot be made by mixing and from which all other colours are made. Ideally you will need several of each to cover the warm and cool aspects of the hue. For example, although blue may be regarded fundamentally as a cool colour, you should include warm and cool versions, such as ultramarine (warm) and cobalt (cool). Added to this you will also need a black and a white.

MANUFACTURERS' BOXED SETS

Several manufacturers make starter boxes of pre-selected pastels, numbering no more than 18 in most cases. These selections are often made according to the subject matter – for a portrait, landscape or seascape. A 'portrait' box, as you would expect, would contain more red and brown tints, whereas the 'landscape' selection has more green-related colours, including blues.

THE LANDSCAPE STARTER BOX (ROWNEY)

COLOUR	TINT
Crimson lake	6
Cobalt blue	2
Indigo	4
Lemon yellow	4
Yellow ochre	0
Purple grey	4
Green grey	6
Grass green	6
Olive green	8
Sap green	5
Burnt umber	4
White	cream shade

THE PORTRAIT STARTER BOX (ROWNEY)

COLOUR	TINT
Poppy red	6
Crimson lake	6
Red grey	2
Yellow ochre	4
Yellow ochre	0
Blue grey	6
Hooker's green	1
Madder brown	8
Madder brown	0
Vandyke brown	6 (hue)
Burnt sienna	0
Burnt sienna	2

PAPER

Having looked at the nature of pastel, we should now consider what sort of surfaces are available to work on. In theory it is possible to work on anything from tracing paper to a brick wall, but there are several things you should consider before choosing your support. Contrary to belief, the simple composition and high pigment density of pastels makes them a very permanent medium – perhaps the most permanent of all. The only element that can affect this is the paper used. What will ensure that your pastel works survive is that the paper is strong with enough texture, or tooth, to hold onto the pastel particles. Therefore it makes sense to avoid cheap, flimsy paper which will darken and become brittle with age.

Weight

A good paper to start off with, and one of the most popular papers for pastel, is Ingres paper. This is a laid paper, with visible mould lines running through, but a basic drawing paper and therefore fairly thin, 90 gsm (42 lb). Ingres paper comes in a range of colours and shades and most manufacturers produce an inexpensive pad with a selection.

A paper favoured by many pastellists is Canson Mi-Teintes which, at 160 gsm (75 lb), is almost double the weight of the Ingres paper. It has a good robust surface which will take a lot of overworking and comes in many shades. Pastel papers of this weight are also made by other companies and are available in pads as well as separate sheets.

Many pastellists like to prepare their own papers by taking a sheet of watercolour paper and adding their chosen tone (see page 10). Here the range of paper available is quite substantial and includes hand-made papers which reach weights of

TIP

If you mount your own work with mounting card, save the window which is left behind. By gluing pastel paper to them, you can make your own pastel boards.

TIP

Remember that it is not always necessary to buy ready toned paper. Apply a watercolour wash of your choice to watercolour paper. The advantage is that it will not be so uniform in tone.

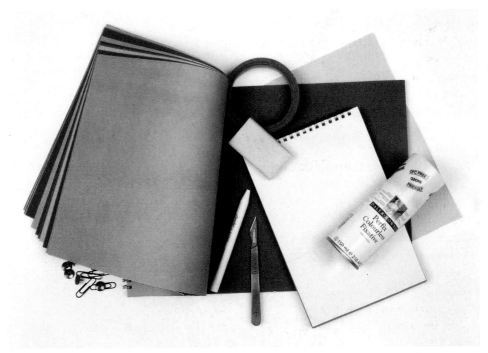

A useful pad of pastel paper showing the range of colours and tones. Watercolour paper comes in different textures and can be toned with a watercolour wash. Not many extra materials are needed for pastel painting: clockwise, from right, cannister of fixative, scalpel, torchon, drawing pins and paper clips, masking tape, putty eraser.

TIP

If you wish to tone a
lightweight paper with
a wash, you will need
to stretch it first. Soak
the paper in a large
tray, or the bath, for
about an hour and
then, using wetted
gummed paper, stick it
down onto a flat board.
Don't worry about
small buckles, these
will disappear as the
paper dries and
contracts.

TIP

When you block in the
foundations of a pastel
painting with
watercolour, use the
largest brushes
practical. This will stop
you getting too carried
away with the
watercolour painting.

425 gsm (200 lb). These papers will take any amount of knocking about, allowing for plenty of overworking, scratching out, scrubbing and even washing.

Pastel board

An alternative to paper is pastel board which is standard paper mounted on board. This has the advantage of being easier to work with, in as much as the paper keeps flat and does not move or buckle. However, in terms of touch, they will only be as good as the paper glued to the board.

Texture

The texture of the paper used is perhaps the single most important issue for a pastellist and each individual will favour a particular surface. The texture chosen will depend on the style of the pastel painter. For example, the relatively smooth 90 gsm (42 lb) Ingres papers have a limit as to how much pastel dust will adhere so, unless intermediate fixing is applied, it is best for fairly sketchy, quickly resolved work.

The 160 gsm (75 lb) pastel papers are more robust but will differ between manufacturers. In the case of Canson, their paper has a deep texture on one side, while the reverse is a little smoother. This is very useful to the pastellist because, within the same pack or pad, quite different effects can be achieved.

Watercolour paper has a wide selection of surface texture from smooth to very rough. Some are mass produced and fairly mechanical, with predictable, regular surfaces, while others, such as hand-made rag papers, have a wonderful irregular and often deeply textured surface which can be enhanced with a watercolour wash.

Glasspaper

Glasspaper has become an indispensable item for many pastellists. For many years, finest grade 00 glasspaper has been used for its extraordinary surface which will hold pastel beautifully and permits almost limitless overworking. Now it is possible to buy artists' quality glass paper. It is expensive but this will ensure that it lasts and will not react with the pastels. However, cheaper glasspaper made for DIY enthusaists is certainly good for practising on. Either way, the abrasive surface uses huge amounts of pastel.

Recipe for sanded paper

You can make your own textured surface like sanded paper. Using acrylic paint – or gesso which can be bought ready-made – mix in the finest grade washed sand. Apply to thick paper or card immediately before the sand sinks and allow to dry. Children's play sand is suitable.

TIP

Works on sanded paper tend to accumulate far more
pastel than other papers and can be rather difficult to
store - a gentle tap will dislodge the pigment. Store
these pastel works flat and covered with tissue paper
if they have not been fixed.

Other textured surfaces

Other textured surfaces can be made by gluing fabric onto cardboard or board. Rabbit skin size is the best glue, but PVA glue available from any stationer will do the job perfectly well. For different effects, try various textured fabrics from muslin to canvas, applying the glue to the support and then laying the fabric on top. For a less abrasive surface, prime with acrylic gesso.

TONED PAPERS

Pastellists tend to use toned backgrounds for their works. For the beginner they are useful as a mid-tone against which to judge the pastel tones, even if the colour is

eventually covered by the opaque nature of the medium. Many pastel painters, however, allow touches of the toned background to show through their finished works, acting as a unifying force over the surface of the painting. Consequently the choice of colour can be important.

If in doubt about what colour to choose, go for something neutral until you are more confident about how colour works. As a general guide, assess the overall general colour of your painting, and choose a complementary tone – the colour opposite in the colour spectrum – red/green, violet/yellow, orange/blue. So pink flesh colours will look good against a greenish background, whereas landscapes with a lot of green will look better on a pinkish or brownish surface. It is simply because of the effect of the opposite nature of the complementary colours; you will find that they register far better than against the same sort of colour.

There are lots of ways of toning white or cream paper, from applying a wash of watercolour to airbrushing. Dry toning involves crushing leftover bits of pastel to a powder under a knife and applying it to the paper with a rag or soft blending brush. For a different effect, wet the rag and dip it into the powder before applying it.

OTHER EQUIPMENT

Apart from the basics, pastels and paper, there is very little else that you need to get you started. However, there are a few items which will certainly help to make things go a little more smoothly.

Drawing board
A firm surface is advisable to support your work because drawing pads do not really offer enough support and you may well want to use separate sheets. The board does not have to be anything special and a

sheet of plywood or MDF would be quite adequate. For a more sympathetic surface, staple a piece of cardboard or even sheets of newspaper to your board under your paper. This will also stop the texture of the board showing through in your finished work.

Easel
This is optional and will depend on the sort of work you do. Up to a certain size it is quite possible to work on your lap, but if you wish to work large then an easel will become necessary. If you do invest in an easel look carefully at the lightweight ones on offer and choose one that will be easy for you to carry outdoors. For indoor work, there are some very good cheap table-top easels which will take quite a big board and allow you to adjust the angle.

Storage box
It will not be long before you want to add to your initial collection of pastels and therefore need to find a larger box. You can customise any box if you have saved the plastic supports from bought sets for re-use. If a box is to be made, then something with at least 12 compartments is advisable. Do not make the box too deep: a depth of a little more than the pastel is best as this will ensure that they do not bounce around.

Some enterprising students of mine have been to DIY stores and found lightweight plastic storage boxes. While these were originally intended for storing things like screws and nails, they can easily be converted into pastel storage boxes.

> **TIP**
> Always save even the smallest fragments of pastel because these can be crushed to a powder and used to 'dry tone' paper with a rag.

> **TIP**
> Tried and tested alternative toners for paper are tea bags, dabbed across the surface, or cold coffee. Both are quite permanent.

> **TIP**
> Paper is fundamental to the pastellist, so it is important to try out as wide a range as possible to see what suits your particular approach. Many retailers are happy to make up a sample book for testing for a small sum of money.

'Bits' box

One of the most infuriating aspects of pastels is that they do break and crumble very easily and ultimately wear down to a small piece. When they get to this stage, I have a small box where all the little stumps go, regardless of their colour. This 'bit box' is often useful for starting off a picture by covering the surface with almost anything that comes to hand. Quite often I have used the very last little bit of a pastel stick by crushing it with my thumb, on the paper, and smudging it into place.

Charcoal

Charcoal is probably the oldest drawing material in the world. It is thoroughly permanent and ideal for underdrawing in a pastel painting because it can be wiped away with a rag or finger and combines perfectly with hard and soft pastels. The best charcoal comes from carbonised willow which is obtained by burning the wood slowly over a period of time.

Fixative

'To fix or not to fix', this has always been a vexing issue for pastellists. The essential beauty of pastels rests to a great degree on the sparkling dusting of pigment resting on the surface of the paper. Fixing it removes subtleties of texture and tone so that a great deal of the charm of the medium is lost. Effectively, once a fixative has been applied to the pastel dust to bind it, the nature and balance is altered. In addition many of the fixatives on the market will darken both the pigment and the paper.

It is for this reason that most pastellists avoid fixing their work wherever possible but patrons of their work like to know that it will last and not fall off the support as the result of a gentle knock. A compromise can be reached with intermediate fixing where the pastel is fixed at various stages to hold the pigment in place, with the final layer left unfixed in all its glory. If final fixing cannot be avoided, then the only commercial fixative I could wholly recommend is Fixativ Lascaux (see page 94 for suppliers).

It is perfectly possible to make your fixative and apply it with a blow spray (see below). For further recipes, refer to *The Artist's Handbook* by Ralph Mayer (Faber & Faber: 1991) and *The Materials of the Artist* by Max Doerner (Rupert Hart Davies: 1934).

Recipe for fixative

It is possible to use gelatine applied with a blow spray diffuser as a fixative. The proportions are roughly one heaped teaspoon to 500 ml water. The gelatine must be applied while warm or it will set to a jelly. Don't use this recipe on sanded paper. In my experience it will darken to some degree with any fixer, but more so with gelatine.

Applying fixative

When applying fixative, the golden rule is never spray from too near to the picture or this will result in blotches and possibly running. Whether you are using a blow spray or aerosol, it is always better to apply two or three thin coats, from a distance of roughly two to three feet, rather than one thick coat. Keep the spray on the move in a to-and-fro action so that it does not get the chance to build up in one spot.

> **TIP**
>
> When finished, you can fix your pastel from the back, thereby fixing the initial layers through the paper.

> **TIP**
>
> Remember that the coarser the paper and deeper the weave, the less need there will be for intermediate fixing.

Useful for underdrawing, charcoal, right, is sensitive and easily erased. Use pastel pencils, left, for linear details in the final stages of a pastel painting.

Other materials

On paper, a torchon is useful for blending small areas of detail, although fingers are more useful for larger areas. You can make your own torchon by rolling up a piece of paper tightly across the diagonal – rather like the old-fashioned paper spills for fire lighting. A putty rubber is useful for lifting out pastel (see page 16). Ordinary rubbers cannot be used as they smudge and make a mess. Otherwise, a few standard bulldog clips or drawing pins will be useful for holding the paper to the board.

TIP

Other blending tools you can try are a soft sable brush, cotton wool, or a putty eraser.

Keeping clean

Pastel is a messy medium. To save your dirty fingers transferring the dust from one area of colour to another, clean your fingers on a rag or apron or keep a box of moist wipes to hand. Pastel dust will fall on your clothing too if you use a drawing board on your knee, so cover yourself well and the floor beneath you if that matters. Working at an easel will save your clothing but not the floor.

TIP

If you use a torchon regularly for blending, be sure to clean it occasionally or it will transfer colour to areas where it is unwanted.

Techniques

Now it is time to pick up a pastel stick and try it out. It is only by doing this that you will discover what they can do. Once tried, it will be difficult to stop; the spontaneity of the medium will captivate you. To create a finished picture, first you need an idea and then you need to be able to express that idea in your chosen medium. The first stage of your pastel painting will involve exploring your idea in sketches and drawings, and then making an underdrawing on your pastel paper. Then comes a general covering of the main areas of colour. The next stage involves a wealth of different textural marks to build up form, tone and texture.

GETTING STARTED

In my experience, it is the first few strokes of a pastel painting which give my students the most problems. It is the perennial problem of all artists: the demands of the blank piece of paper.

A quick sketch made with a pen of a character at the Venice Carnival. Jotted colour notes help when, later in the studio, the sketch is worked up in pastel.

A way of getting around this is to begin with a preliminary drawing – just a few lines to break the ice and overcome the block. The complexity of this initial drawing will depend on the subject – a few lines of charcoal, a guide for areas of colour, or a more complicated fully-worked exploration of the subject.

Underdrawing

For whatever reason, most artists do like to make a preliminary drawing before applying colour. Occasionally it is possible to work in colour straight away, such as the small and spontaneous landscape of *Morston Marshes* on pages 34–5. However, as a subject, this requires little or no drawing, unlike *Farmhouse, Les Planes* on page 55 where there are intricate areas of colour that need to be defined accurately. You can use pastel or chalk for the underdrawing but I prefer charcoal as it can be wiped away easily with a finger or rag and can also be quite precise (see also *Boy with Candle* on pages 24–7). Avoid pencil or graphite as they repel soft pastel and can leave unwanted indentations on the surface.

Using sketches

A sketchbook is the ideal way of collecting visual ideas – a view from a bus, an interesting rock formation, or a magical cast of light. A sketchbook can fit into a pocket, be whipped out at a moment's notice, and the resulting pencil drawing, with notes about colours, will convey a great deal of information. Add a small watercolour box with a thumb ring to your pocket and you will be ready to sketch anything. Carry a few pastel sticks in a small box to take advantage of the immediacy of the medium.

Any first-hand information gathered in this way is vital for a studio-based composition. Look out for contrasts of both tone and colour – check for the brightest and darkest parts of a scene and add colour notes to pencil drawings; indicate the direction of light; if there are figures, make a note of their scale to the surroundings; and always be aware of where your eye level is. The aim is to give yourself enough material so you can develop ideas away from the scene later on.

To preserve the immediacy of the sketchbook drawing, you might want to trace the original and transfer it to pastel paper. First of all, trace the original work with pencil, then use a Conté stick to cover the image on the reverse of the tracing paper. Retrace the drawing from the correct side, using a little extra pressure, and the drawing will appear on the pastel paper. Ordinary carbon paper also works well.

BROAD COVERAGE

Pastels, as well as chalks, can be removed from their wrappers and used on their sides to cover an area speedily. Because pastel is reduced to pure pigment once it has been applied, you can add water to this with a soft brush to form a type of wash. Once dry this can be worked over in pastel again because it has effectively been fixed. However, it is not always necessary to add water. An area broadly rubbed in with fingers or a rag makes a good base to work over.

Blending

Although pastel may not blend as easily as paint, it is still possible to cover areas quite quickly by using your fingers to smudge the strokes. By putting down two or three soft pastel colours side by side these can be blended with the fingers swiftly to obtain a good approximation of the colour and tone you will finally need. However, the amount of blending does depend on the degree of texture on the paper surface – more texture, less immediate blend.

For initial 'rough blending' the fingers or a piece of rag work perfectly well. A dry bristle brush is useful if the texture of the paper is deep. As the picture progresses, a torchon is more capable of producing finer and controlled blending. Using the pigment already on the surface, the torchon can be used almost like a pencil to push the colour around as well as to soften edges. See *The Circus* (page 18), *Beach Huts, Walberswick* (page 39) and *Still Life with Stripes* (page 81) for some blending examples.

Once the first layers have been completed in this way over the whole picture, you are ready for some overworking in the form of feathering, hatching and cross-hatching.

ADDING TEXTURE

Texture within the context of the drawing or painting refers to optical textural effects. This is not to be confused with physical texture such as the weave of the paper or the gritty surface of sanded paper. It is

texture such as the weave of the paper or the gritty surface of sanded paper. It is more to do with the use of, say, hatching or cross-hatching when describing such forms as grass or hair (see *Farmhouse, Les Planes*, page 55) and highly rubbed smooth surfaces when drawing shiny metal or satin (see *Still Life with Hat*, page 76).

Feathering

This is when a base colour is superimposed by separate strokes of a different colour thus creating an optical blend of the colour. You can see below how the optical effects of using the same two colours overlaid can produce different results according to which was applied first. It also produces an interesting texture. Feathering can be used to rescue areas that have become tired or overworked as it can liven up the surface texture considerably.

Feathering strokes can be used to mix colours optically. The result is different depending on which colour you lay down first.

Hatching and cross-hatching

Areas of hatching are built up of roughly parallel strokes. Cross-hatching merely superimposes hatched strokes with more of the same, usually at right angles to the first. Hatching and cross-hatching can be used to create form, texture, tone, and to mix colours optically. So much mixing in pastels is optical. By this I mean the effect of orange perceived by the eye when several strokes of yellow are hatched and then cross-hatched with strokes of red. Together they combine, optically, to make orange even though the individual component parts remain unaltered. The orange is caused by the effect the two colours have upon each other. You can see these effects in *Josh's Camp*, page 67, and *Boy with Candle*, page 27.

Stippling

Stippling involves repeated marks in an almost staccato way usually over the top of a base colour (see opposite). Try some different stippling marks – sharp dots of pure colour, or less defined marks. This will give you different effects. For sharper marks you may need to create an edge on your pastel with a blade. If you twist the stick as you lift it off more pigment will be left behind.

Lifting out

Although using an eraser is usually associated with the removal of mistakes, it also has an important constructive use with pastels which is to create highlights. Sometimes an area which needs to be left unworked with the toned paper showing through can become smudged or gone over accidentally, in which case the lights can be lifted out or 'drawn in' with a putty eraser. Making sure it is well warmed by the heat of your hand, lift away the colour with a dabbing movement, turning the putty as you go. You will find that a piece of soft bread will also do the job quite well.

Mix colours with stippling or use them to provide texture. If you twist the pastel stick as you lift it off, a sharper mark will result.

Mixed media

For special textural effects, try mixing pastels with other media. Naturally, it is better to combine those media which are in sympathy with each other and this is mostly a case of trial and error. In the case of pastel, watercolour is an excellent companion as it can cover large areas quickly and cleanly. A series of such washes can set a picture off to a flying start before work is started in pastel. There is also no limit to the number of alternate layers of pastel and watercolour you add. Once water is brushed onto a layer of pastel pigment it becomes like paint and will dry as such. It can then be worked over with either more pastel or another watercolour wash. Charcoal also behaves in the same way. See *The Mill Pond*, pages 20–21, and *Girl with Towel*, page 73.

Further texture

There are many more ways of creating texture, limited only by the imagination of the individual. Try scratching out with a blade, using a wax resist like a candle and even scrubbing with a stiff brush, perhaps a toothbrush.

FINAL DETAIL

The final part of a pastel painting can involve adding fine details – shimmers of light on a lake, fine lines of highlight on a head of auburn hair. These last details often bring a pastel painting alive, focusing the eye on certain areas and adding lines and points of pure colour.

Fine lines

Fine lines can be rather difficult to achieve with soft pastels, so if precise lines are needed use hard pastels. Those which come in square stick form have a useful edge for lines. Alternatively, a point can be sharpened with a blade and then, for added control the chalk can be held in a holder. Depending on how soft a pastel is, it should usually be possible to bring it to a point by rubbing it very gently with sandpaper.

One of the most effective ways of obtaining a sharp line is to use pastel pencils. These sharpen to a precise point and have the advantage of coming in a wide range of colours.

The general texture of pencils is harder than the chalk pastels but you need to try them to see what you can achieve with them. See *Carnival Characters* on page 68, and *Flower Study*, page 79, to see the effects of sharp lines and fine detail.

WORKING FROM SKETCHES AND COLOUR NOTES

The circus is always a colourful and exciting subject and this pastel was constructed from sketches and colour notes made from several performances. Working from drawings made on the spot is a challenging but highly rewarding activity. The more you do it the better you become at knowing exactly what information to seek out when you are on location – it produces a record of your own interpretation.

Over a number of trips to the circus, I made several drawings in pencil of the various characters. Added to these were written colour notes as a reminder of costumes and background material. I also used a small watercolour box to achieve more precise records of colour.

Once all the information is gathered, then the exciting task of assembling everything into a composition begins. The composition was established in charcoal in an underdrawing on the grey toned paper.

Charcoal can be pushed around and removed very easily just with a fingertip.

The broad areas such as the tent background and elephant were smudged a great deal with the fingers to blend quickly and make a base cover. The purplish colours were a mix of Prussian blue, ultramarine and pansy violet; the elephant, a mix of ochres, umbers and grey.

One of the most attractive aspects of this subject was to be able to use all three primaries as local colour – the reds, yellows and blues of the ringside and marquee. Complementary colours, such as purple and orange, blue and yellow, were naturally present in the scene and therefore brought out.

The general application of colour in this picture is quite loose and both fingers and torchon were used extensively to blend. To finish, careful details were added in places, like to the man on stilts and the edge of the ring.

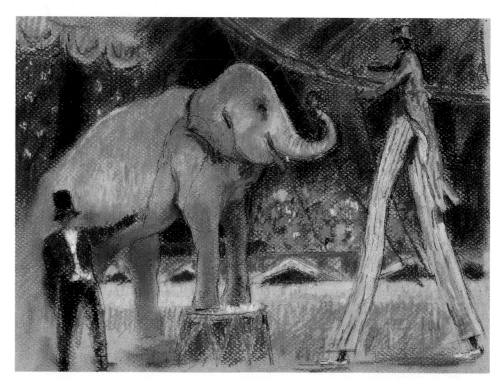

CIRCUS, 24 x 32 cm (9½ x 12½ in)

EXERCISE – BLOCKING IN WITH WATERCOLOUR

Often, especially with larger pieces of work, it helps to get the picture moving along more quickly by laying the foundations with a watercolour wash. If you are starting on a white paper then blocking in the areas of colour with watercolour can rapidly advance the painting to an exciting stage. In addition, the transparency of the washes adds a great deal of charm to the final pastel painting. Start painting as you would an ordinary watercolour, but there is not the same desperate need to preserve the white paper, giving a little more freedom and flexibility to these early washes.

WATERCOLOURS
- **Reds** – alizarin crimson, cadmium red, Vandyke brown, burnt sienna
- **Blues** – ultramarine blue, Prussian blue
- **Yellows** – yellow ochre, lemon yellow
- **Other** – Payne's grey, cadmium orange, Hooker's green

PAPER
- Watercolour, hand-made rag, 300 gsm / 140 lb

BRUSHES
- Large, soft, round, no smaller than no. 7

Stage one
Once you have decided on your composition and have marked out the rough proportions, use a charcoal pencil to make a basic drawing which outlines where the broad masses of colour and tone should go.

Stage two
Now block in the outlined masses with dilute washes of watercolour. Work fairly quickly using large brushes (no smaller than a no. 7) to keep the statements broad. To what degree you develop such a watercolour beginning depends on your objectives. I personally prefer not to take the watercolour too far, leaving plenty of scope for the subsequent layers of pastel. Leave to dry before working into this base colour with pastels (see over).

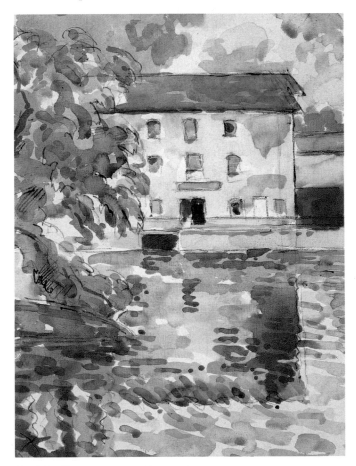

THE MILL POND

EXERCISE – WORKING INTO A WATERCOLOUR WASH

Once the wash is completed, the pastel can then be used to develop the painting, adding texture and tone – what it is suited to do. With the broad covering established, the textures of the building, foliage and water can be explored using the optical techniques so special to pastel. Remember that there is no need to try and cover up the wash. In fact, it is important that it be seen to be interacting with the overlayers of pastel.

PASTEL COLOURS
- **Reds** – madder brown (0,8), poppy red (4,6), purple grey (1,4,6)
- **Blues** – blue grey (2,6), ultramarine blue (6,8)
- **Yellows** – cadmium yellow (2,4,6)
- **Greens** – lizard green (8), olive green (6,8), sap green, (4,6), Hooker's green (2,4), viridian

Stage one
Lay down the initial layers of pastel, some blended with the fingers, others left as hatched strokes. The picture starts to come to life quite quickly, well served by the watercolour underpainting.

Stage two
Now, the reflections. Pastel is very suitable for this type of execution and on this scale. Reflections are such that the water appears to be made up of a series of small, well-defined areas. The chalk and pastel pieces work beautifully when making concise and succinct marks of individual colours. Reflections often seem to contain a myriad of different colours, due to the continuous breaking of the water surface. With the ripple strokes going the same way, one has relative freedom with the colour, providing a springboard for some genuinely creative colour-making.

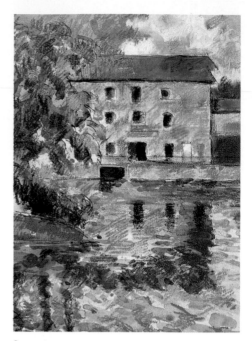

STAGE 1

Stage three
More work is done at this stage to improve the relationship between the willow tree on the left and its background. When trees are seen against a pale sky or building, in order to get the effect of shafts of light filtering through, it is sometimes easier to add in the background as a positive series of marks. By dabbing in cream pastel marks over the foliage in front of the mill, and pale blue in front of the sky and river, this has the required effect. This is one of the joys of working in an opaque medium such as pastel.

Finished picture
Add final touches to the water and tighten up the reflections of the trees in the foreground. The sky is also strengthened to balance out the extra work done on other areas. The final result is a fully opaque pastel painting, but with the watercolour underpainting, still quite evident in parts, providing a unifying key to the whole picture.

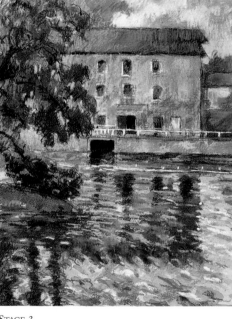

STAGE 2

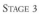

STAGE 3

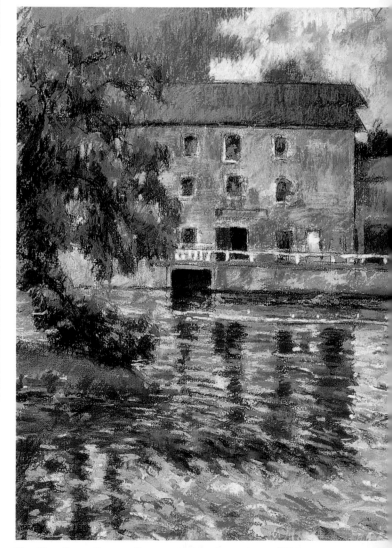

THE MILL POND, GRANTA, CAMBRIDGE, 44 x 32 cm (17 x 12½ in)

Colour and Tone

The study of colour and tone is fundamental to all aspects of drawing and painting. The main thing to remember is that all visual art revolves around the actual practice and, although it is obviously useful to have a theoretical knowledge, the surest way to learn is by your own effort and the exciting discovery that goes with it.

PRIMARY COLOURS

All colours that we see in nature are derived from three colours which we call primary colours. These are red, blue and yellow. What makes them significantly different from all other colours is that they cannot be mixed or made. It follows therefore that as artists if we are to attempt to reproduce what we see we must have at least these basic three. Add to these three a black and a white and you have just about all you need to paint anything you want.

Primary colours – red, blue, and yellow – cannot be mixed from other colours. But note how both warm and cool versions of primary colours exist.

Unfortunately, with pastels it is not quite that simple. Pastels do not mix so readily as paint and can become muddy very quickly. To get round this problem we need to have several versions of each primary, ranging from warm to cool.

Secondary and tertiary colours

If primary colours are mixed you obtain a secondary colour: red and yellow make orange; blue and yellow make green; red and blue make purple. When secondary colours are mixed, tertiary colours result, mostly browns and rich greys.

Secondary colours are mixed from two primaries but the result is affected by whether warm or cool primaries are used.

COMPLEMENTARY COLOURS

When seen together, these possess a natural harmony. Mix two primaries to make a new colour and the remaining third primary will be its complementary. For example:

blue + yellow = green – complements red
blue + red = purple – complements yellow
red + yellow = orange – complements blue

Complementary colours have a natural harmony and also when seen side by side create an optical buzz. This energy, which is apparent even in weak tints, can be harnessed in your pastel paintings.

CREATING SPACE AND DISTANCE WITH COLOUR

In a painting, distance can be suggested though aerial perspective, where tones and colours are made progressively paler and cooler the farther away they are. This results in a blue or purple in the farthest distance to suggest ambient atmosphere. This is most noticeable in landscapes where the eye can see into the distance more readily.

Colours also tend to contain innate characteristics in relation to space. Blue always goes back in a painting, whilst red will be a colour that comes forward. Secondary colours can both recede and come forward, whilst tertiary colours will tend to be used in the middle to far distance.

Greys

There are greys of all casts – blue-greys, pinkish-greys, ochre-greys. These are generally referred to as 'coloured greys' and are obtained by mixing several colours with white, but usually bearing a bias towards one colour, rather than just a straight mixture of black and white.

Tone

In the past, artists would often make a full tonal underpainting and eventually work over the top with colour only when the composition and mood of the picture were fully established, rather like the early photographers would hand colour a black and white print. Nowadays most artists prefer to launch straight into colour, but there is a great deal to learn in making a monochromatic underpainting such as the *Boy with Candle* on pages 25-7.

TIP

Rich coloured greys can be created by mixing complementary colours, eg blue with orange. Blend the blue and then superimpose strokes of orange.

You may also find it useful to make a tonal study of your subject, in pencil or charcoal, so that when you begin to work in colour you have some idea of distribution of tones over your picture. You may hear from those who have tried working in pastel that dark tones are difficult to achieve. Certainly there are far more lighter colours available and it can be a challenge to make a dark tonally equal to another lighter colour within your picture. Practice and familiarity with your range of colours will help with this, as will tonal studies, as in the studies of young boys on page 64.

> **TIP**
>
> For a tonal study, use a mid-tone pastel paper, searching out the darkest and lightest areas first with black and white chalks. If you screw up your eyes, you will find it easier to isolate these extremes of tone.

CONTRAST

Contrast, the difference between the darkest dark and the lightest light in a painting, is vitally important and can give your work that heightened sense of reality if it is properly understood. For instance, on a bright sunny day the shadows will be dark, crisp and clearly defined and the highlights bright. On dull, overcast days, or if the subject is seen through diffuse light, the difference between the shadows and the brighter parts of the painting will be less pronounced, and consequently contrasts will be far less evident. Strong contrast is often present with artificial light, which will produce very definite cast shadows, an effect exaggerated with spotlights.

In addition to the extremes of contrast, there are all those half tones that exist between the light area and its passage into dark. The term given to this arrangement of lights and darks is tonal values. That is to say a correct balance, relative to your subject, of the value of one tone to another.

LOST AND FOUND EDGES

This is a lovely term which refers to those edges, particularly with regard to indoor subjects, which are lost, or not visible, because they are the same colour or tone as their surroundings, merging into the background or neighbouring passage. The 'found' part is the lighter edge, which is usually seen against dark and is therefore much sharper. Rembrandt was one of the greatest exponents of this technique.

> **TIP**
>
> The beauty of pastel is that you do not always have to cover the page with colour. Try taking a drawing that was made in monochrome and simply adding some local colour in pastel.

Demonstration

Working in monochrome

For centuries candlelight has been a major subject for artists. There is a quality of light present with candles which is not to be seen with electric light, nor does artificial light contain the same mystery. It was this mystery and magical feeling of moving shadows that probably attracted my son to ask if he could eat his supper by candlelight.

The key to capturing and understanding this very special subject is to study the exact fall of light and the tonal pattern that results. It was for this reason that I chose to make what was effectively a monochromatic underpainting.

Method

1 Using a dark blue paper, a tonal study was made with charcoal and white chalk. The white was used for those obviously light areas lit up by the candle, while the charcoal added the shadow darks. The paper left bare held the

COLOURS
- **Blues** - Prussian blue (6), ultramarine blue (6,8)
- **Reds** - burnt umber (6,8), purple grey (6,8), poppy red (4), reddish purple (3), burnt sienna (3), madder brown (0)
- **Yellows** - cadmium yellow (2,4), lemon yellow (2,4), yellow ochre (0,2)

PAPER
- Ingres dark blue toned pastel paper, 160 gsm/75 lb

whole work together representing the half tones. The effect, even at this early stage, is actually quite similar to that of candlelight where the light illuminates high points and then falls rapidly into darkness. From a pictorial point of view, it is also holding together well as a composition.

2 With a well-defined tonal underdrawing, colour could be laid down quickly and effectively, once more demonstrating

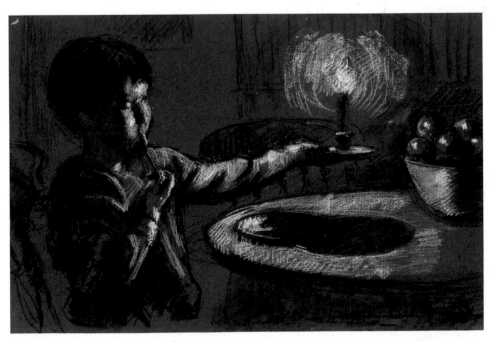

BOY WITH CANDLE, STAGE 1, 31 x 36 cm (12 x 18 in)

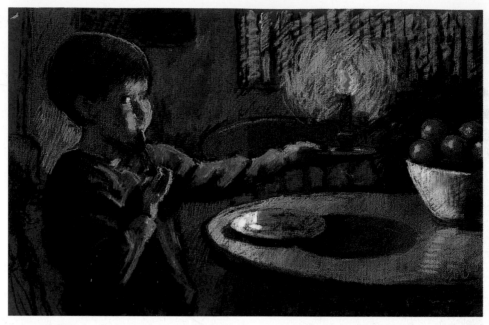

BOY WITH CANDLE, STAGE 2

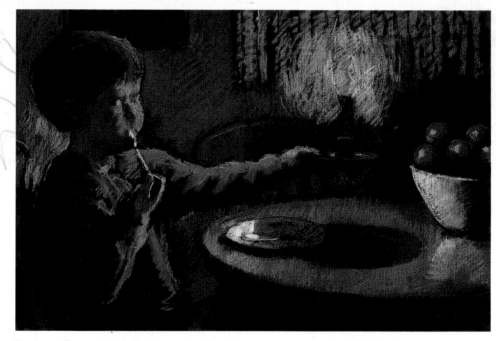

BOY WITH CANDLE, STAGE 3

how wonderfully adaptable pastel can be. At this point the colours used were very simple and few, relying on the strength of the underpainting. Because of the nature of candlelight and the way it reduces the amount of colour observed, it was quite important to begin with a restricted palette and not be tempted to add a wider variety. Adding more colours might also have reduced the simplicity, and thus the impact, of the scene.

3 Some further gradation of colour was applied here, for example, on the hair, jumper and table top. Also, some

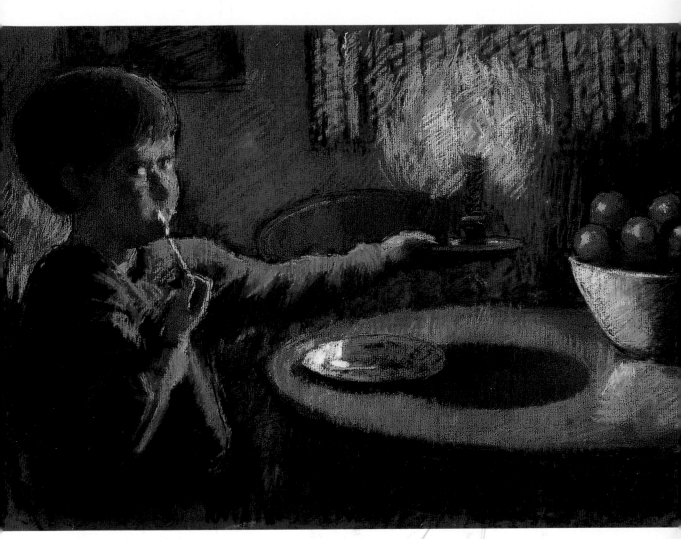

BOY WITH CANDLE, 31 x 36 cm (12 x 18 in)

highlights were added on the fork and back of chair to give some clarity. Notice also how the hatching is built up on the table top. This becomes increasingly possible as the surface is built up, using the underlayer as a base upon which to hatch over.

Also, to the light ultramarine blue first covering on the boy's jumper a reddish purple was added, tint 3, put on in a downward hatching method. This was done carefully so as not to cover the blue completely but instead make an optical mix of the two colours.

4 Because the general form of the picture took shape very quickly at this point, all that was left was to refine certain areas and make them more subtle. The boy's jumper was overworked again to sharpen the pattern of light. The table top was also overworked with downward hatched strokes to improve the texture. Finally, the face had some gentle drawing added just to define the expression a little more.

Notice how the background has been kept simple throughout, with the concentration on those areas most affected by the candlelight.

USING MONOCHROME WITH COLOUR HIGHLIGHTS

Because of its close relationship to drawing, pastel need not always be thought of as a full colour medium, and colour can be added simply in the form of a tint on a ready-established monochrome base. If you have a subject that is suitable, it is a good idea to develop the preparatory drawing in a purely tonal and linear way, thereby giving yourself a chance to get to understand the constructional side to drawing without the relative complexities of colour.

Dancers began as a fairly straightforward drawing from life. Using only charcoal, I concentrated mainly upon getting the shapes and form of the dancers right, before attempting anything else. Once this was achieved, along with the relationship the two poses formed together, I began to think about tone.

Because the colours of the dancers' outfits were quite straightforward, I decided to keep the drawing moving along as a monochrome, but was poised to add the colour at any time. Unlike many of the pastels in the book where colour values are important, and in some cases are almost pointillist in character, this piece of work could almost be described as a coloured drawing.

Having started with charcoal and white chalk, the colours that were eventually added were lamp black, poppy red, ultramarine and yellow ochre. The gradation of each colour was achieved more or less by just using the black rather than seeking to define each area as a separately conceived colour.

Generally speaking, the brighter colours are, the more difficult it becomes to judge their tone. It is also more difficult to judge the relationship to the adjacent colours as the colour boxes in the diagram shows (see page 23). In the early morning or late evening the colour range narrows in terms of brightness, and colours become a greyer version of themselves.

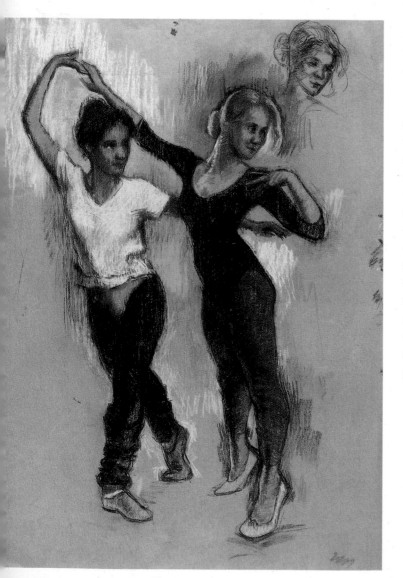

Dancers, 65 x 48 cm (25½ x 19 in)

MISTY SCENE, MUTED TONES

In the picture of King's College, the mist produced a velvety blanket which subdued colours to a muted range of purples, pinks and bluish greys. It is always interesting as well as instructive to work at different times of day as this greatly enhances your understanding of colour in relation to tone.

As I am fortunate enough to live in Cambridge, I have the most wonderful subject matter on my doorstep. This view of King's College on a misty winter morning was magical and was something I had planned to do for a long time. The effect does not last long and the sun eventually dispels the mist. The long eerie shadows were a vital part of this scene and retained their character only whilst the mist lasted, after which they sharpened up considerably.

The composition was drawn in with charcoal, but colour was added as soon as possible. Rather than blend the pastels with my fingers, I decided to build up layers using a cross-hatching technique. The sky contains the lightest tints of purple, reddish purple and blue grey. The greens were mixes of Hooker's green, brilliant green and permanent green in their various tints. The darker areas of trees were from the 'bit box'. The finer drawn lines in the buildings and gate were a mixture of charcoal and Conté stick.

Towards the end of this picture the trees became less like silhouettes and a pattern began to emerge on the bark. Pastel was ideal for putting in the individual patches of coloured bark. The temptation here was to go too far, so I stopped. But I made a note that those trees would make a wonderful subject – another time.

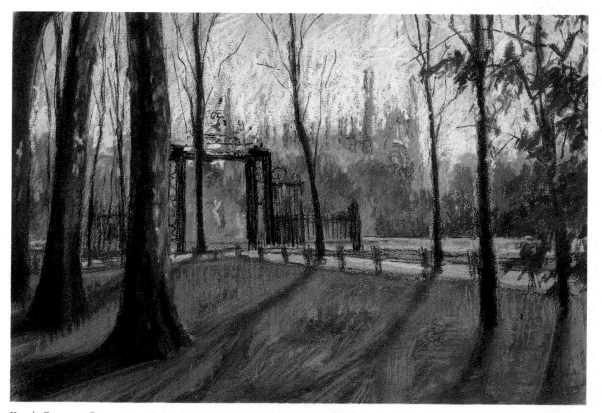

KING'S COLLEGE, CAMBRIDGE – EARLY MORNING MIST, 24 x 32 cm (9½ x 12½ in)

Landscape

Landscape is a constant source of fascination, providing endless inspiration for artists. The medium of pastel is entirely suitable for landscape work, capable of producing any effect you should choose.

Perhaps one of the most difficult things to achieve with landscape painting is the balance between how much work is done outdoors and how much in the studio. There is no absolute rule of thumb and every artist needs to find their own solution.

Most artists would agree, I am sure, that all work, whatever the subject, benefits from working directly from the subject. However, the problem with working outdoors is that there are so many obstacles that interfere with the smooth passage of events. The weather can be a constant source of irritation with wind, rain, cold and shifting light. Ultimately though, this is what we love about the landscape; the fact that it is alive and constantly changing should be regarded as a challenge rather than a nuisance and perseverance will find a way around these trials.

PAINTING OUTDOORS

Painting outside can be exhilarating but you will need to plan your expedition carefully. Keep your selection of colours to a working minimum, not so much because of the weight but in order to prevent wasting time searching for one colour amongst a huge number.

CHOOSING A VIEW

The choice of what to paint can often be rather overwhelming. To help you around this initial stage the use of a viewfinder is an invaluable aid. Once you view a scene through a viewfinder, it immediately

TIPS FOR WORKING OUTSIDE

- Try not to work too large. Coping with big areas can involve a lot of filling in, which is time consuming. Smaller pieces of work can be resolved more effectively whilst your energy lasts and not least before the scene in front of you changes entirely, as inevitably it will.

- Easels and stools should be lightweight and easy to carry for some distance. In fact you should be able to pack your equipment so that it would be possible to make a walk with it if necessary.

- If there is strong sun, try to work in the shade or take a sun umbrella of a neutral shade. Shade is essential for your picture as well as for you as colours are very difficult to assess in bright sunlight.

- Try to find shelter by a bush or tree to keep out of the wind.

- Look at the sun and try to predict what effect it will have on your scene as it moves.

- Cattle can be a problem – it is unlikely that they will hurt you but they do tend to gather around and obscure the view.

makes everything look plausible as a potential picture. Viewfinders can be bought in an art shop, but they are easy to make by holding together two L-shaped pieces of card and adjusting the size of the rectangle they make. Alternatively, cut a rectangle out of a piece of card to make a window and slide a straight piece of card across to alter the proportions. This aspect of altering the proportion is very important because the view you see through your viewfinder must match the proportion of your paper. Holding the viewfinder near to or farther from your eye alters the amount taken in.

The viewing angle

It is always advisable to make sure that you are selecting a good angle from which to view. For instance, sitting down will lower your eye level considerably. This means that if you are in a field, all the grass and plants will become more important and may even cut out some of the distance. This can make a very attractive angle especially when grasses break into the sky area. Standing up or even viewing from a higher vantage point such as a hill will increase the amount you see and offer its own particular possibilities. Always pace around to get the feel of a place and find the best view.

Balance

Generally, it is best not to place main items centrally because this can create a static feel and results in a picture that lacks interest. For example, placing a horizon exactly half way up, or a large tree right in the middle of, a picture will make for a dull effect without any tension. A focal point, or main centre of interest, should be chosen and placed strategically within the rectangle.

Format

Landscapes do not always automatically fall into the 'landscape' shape, where the picture is wider rather than taller. Sometimes the upright format can work extremely well and even a square will offer interesting possibilities.

TIP

Strong winds are one of the greatest enemies of the landscape artist. Always have plenty of clips handy for holding down your paper. Sometimes a small G-clamp is essential to stop your box from taking off.

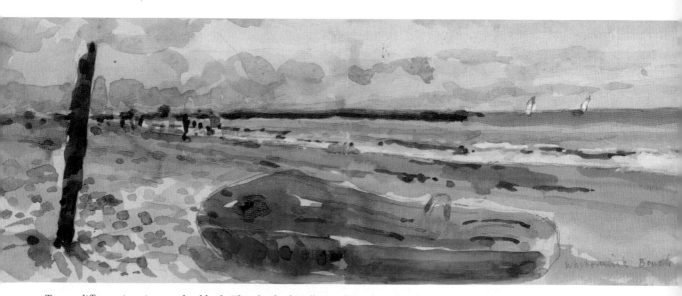

Try out different views in your sketchbook. This sketch of Walberswick Beach was made on the same day as the view developed into the pastel on page 33.

MIST IN THE LANDSCAPE

Mist creates an effect like stage scenery where the divisions of the picture space into foreground, middleground and background, become quite obvious. The mist also has the effect of softening and simplifying the colour. Although heavy mist reduces colours to an apparent neutral grey, you must be careful not to see the scene as a complete monochrome. Scenes such as this illustrate very well the use of 'coloured greys'. That is to say, colours which are much reduced from

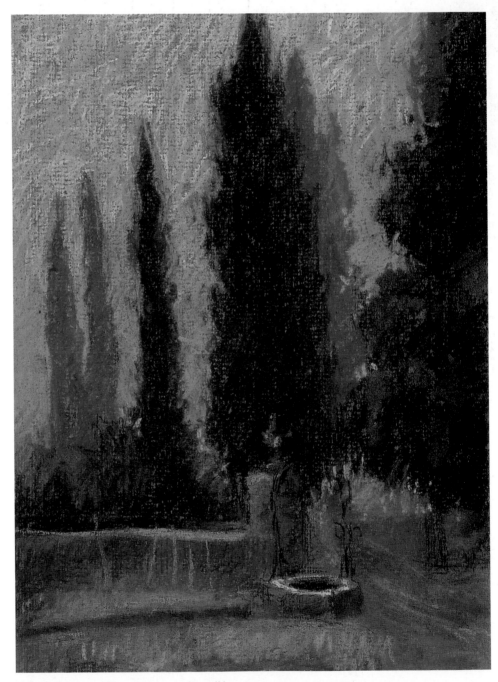

TUSCAN GARDEN IN MIST, 23 x 15 cm (9 x 6 in)

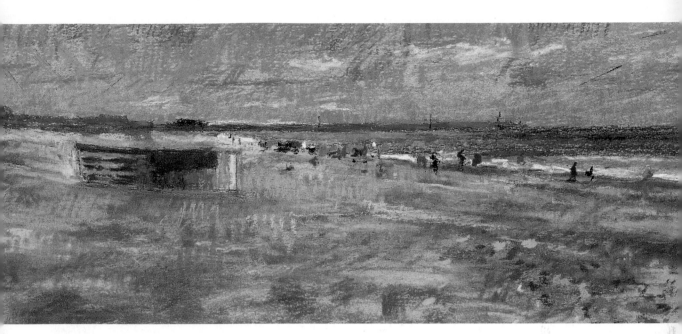

WALBERSWICK BEACH, SUFFOLK, 15 x 32 cm (6 x 12½ in)

their normal bright appearance but which retain a bias, such as a reddish grey. In fact, the potential is endless and great fun to explore. This is the extraordinary quality of the scene shown on the opposite page.

I chose a fairly dark grey paper so that the light pastel marks would show up easily. Because of the simplified nature of the colours in this subject, once again pastel becomes a natural choice. Notice how the cypress trees can be stated in quite distinct gradations of green and then green/grey.

The success of a subject like this depends greatly on keeping the approach simple and resisting the temptation to over develop. The cross-hatching technique works well on this scale and keeps the surface texture lively. The choice of colours here is once more quite simple and easily reproduced using the landscape starter box described on page 8.

BEACH SCENE

Beach scenes are a favourite landscape subject of mine because they are the centre of so much activity, both human and natural. Each day there is a slightly different arrangement of windbreaks and bright colours dotted around the place. The colour of the sky and especially the sun changes constantly, creating a new mood every time.

This picture was done on a bright summer's day and I was able to use a wide range of blues. Aspects of the sky and particularly the sea can be quite turquoise in this bright, shimmering light.

Most of the colours in the picture would be achievable with the pastel starter box, but it would be useful to add turquoise and blue-green in its various tints. However, that is not to say that the scene would be impossible without these additions. Careful mixing and blending of those colours available would produce just as interesting an effect.

The main point to remember is not to be too literal in your approach to colour. Just because you may not have the exact colour you see, it does not mean that the effect cannot be reproduced. The success of a picture is determined by the colour harmonies within it, because comparison to the scene ceases as soon as the work is finished.

Demonstration

Conveying space with colour

This tiny little pastel was made as a direct response to what I consider the ravishingly beautiful landscape of North Norfolk. The marshland that exists between the land and sea in this area contains the most wonderful and robust colouring. The sense of space is enormous as the flat, unrelenting marsh finally meets the horizon.

The great challenge here for an artist is to convey this sense of space with colour alone, because there is nothing in the landscape to indicate any sense of scale. In most other situations there is either a building, person or even a tree to give some idea of scale, but this type of marshland is unique. As a consequence, this can be quite liberating for us as artists, as we must deal with colour without any apparent form. So much can be learnt about the nature of colour and the spatial value that all colour has, regardless of shape or form.

Although at first glance this little landscape appears to be almost abstract, the aim was to give it a sense of space, regardless of whether the viewer was familiar with the area.

COLOURS
- As in landscape starter box on p. 8

PAPER
- Ingres buff pastel paper, 160gsm/75lb

Method

1 Using the landscape starter, I began by establishing the basic colours of the sky with cobalt blue, indigo and additions of green to achieve the turquoise colour.

2 With the tone and weight of the sky established it becomes easier to gauge the colours needed for the landscape. The marshland greens are quite dense, for which the sap green was useful.

3 All the colour in this picture was applied

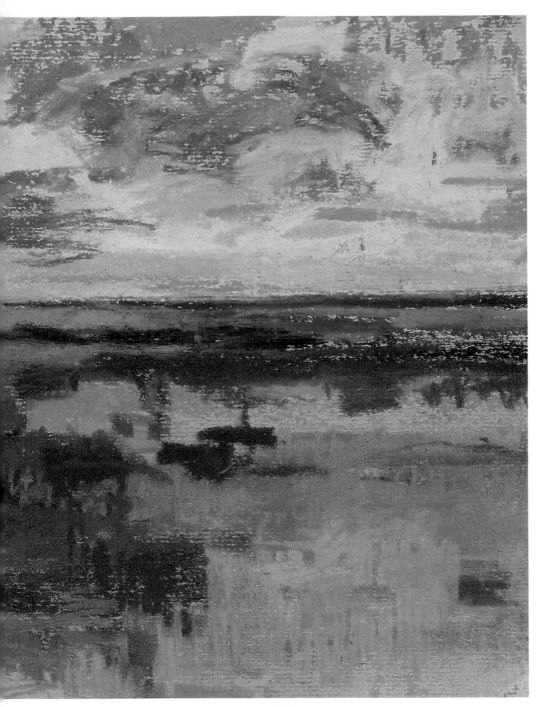

MORSTON MARSHES, NORFOLK, 15 x 19 cm (6 x 7½ in)

in an almost mosaic-like way, by laying blocks of colour side by side. At this stage the foreground marks became broader, using green grey, sap green and olive green.

4 All that was left at this stage was to punctuate the masses with passages like the strip of dark blue sea and patch of rusty orange in the middle distance. This was a very spontaneous and energetic little pastel which tells the story purely through chunks of colour, counterbalanced against each other.

Skies

Skies play a vital part in any landscape. This is particularly so where the ground is flat and the sky dominates, such as in eastern England. It is not surprising that this area has spawned so many great landscape artists. Clouds can move surprisingly quickly and there is often not time to make an in-depth study. The key to capturing a bank of moving clouds is to work broadly, blending swiftly with fingers or a rag and aiming to render an overall effect which describes masses and broad changes of colour.

TYPES OF SKY

Artists throughout the history of art have made series of cloud studies to try and get to grips with the structural aspects of skies. Those of John Constable (1776–1837) are particularly well-known. His studies included notes on the time of the day, the weather and the quality of the light.

There are three main groups of clouds which it is useful to be able to identify: Cirrus clouds – thin wispy clouds spread across a normally blue sky and are high up in the stratosphere.
Cumulus clouds – large puffy white clouds which are also often seen against a blue sky and occur lower down than cirrus.
Cumulo-nimbus – dark and heavy looking, they occur much lower and usually bear rain. Very often they can be seen banking up across the sky almost like a ceiling.

COLOUR IN SKIES

The colour of a sky depends entirely upon the amount of water vapour present. In the southern Mediterranean or Africa the sky can be an extremely dark purplish blue because of the lack of water vapour. In the United Kingdom, however, skies are seldom that blue. For deep blue skies, the darkest tints of ultramarine and Prussian blue should be used unmodified. As the sky approaches the horizon, the blue is weakened and gets cooler, turning through cobalt to a turquoise or cœruleum blue. In some ways the job is made slightly easier for pastellists because, provided you have a range of pre-graded blues, these will often do for gradating a blue sky, by laying strips of these graded blues alongside each other and then blending them together.

More spectacular gradated coloured skies, sunrises and sunsets, can be created with blending and hatching techniques (see *Rome Rooftops*, page 52, and *Sunset over the Dogana, Venice*, page 92).

In any weather conditions there will be a considerable range of colours and these will often be of the 'coloured grey' type. Once again, depending upon your range, many of these 'coloured greys' can be found in the lighter tints of colours like blue grey, purple grey, reddish grey and green grey.

CLOUDS AND AERIAL PERSPECTIVE

The clouds on this typical spring afternoon in north Norfolk seemed to be full of colour. I used the warm quality of the clouds on the right, expressed in yellow and purple greys, to show their place in the foreground, in contrast with the more distant clouds on the left,

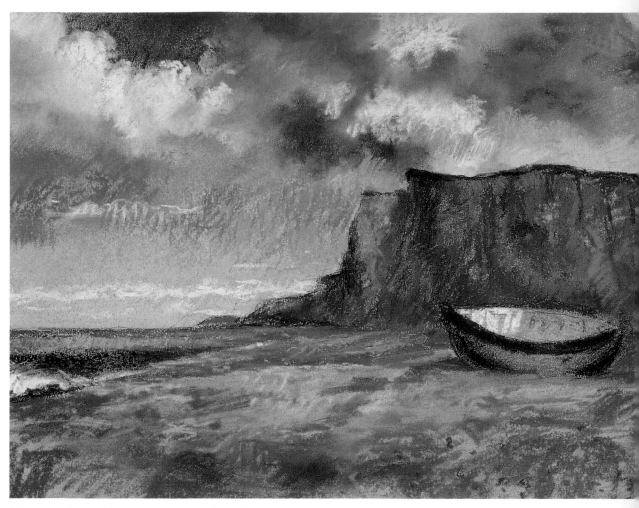

WEYBOURNE BEACH, NORFOLK, 24 x 32 cm (9½ x 12½ in)

expressed in cooler blue greys.

Notice how at the top, left, the deep ultramarine of the clear sky contrasts greatly with the white puffy cloud. The degree of focus and the contrast in tone brings this part of the sky into the foreground. As the sky stretches out into the distance, approaching the horizon, the water vapour increases and all sorts of marvellous pink and turquoise shades appear. But these are kept pale and cool to ensure that they stay in the distance.

Working out of doors in Britain is never a dull experience. The fleeting weather conditions that are liable to exist at any time mean that a landscape artist must be ready to change direction at a moment's notice. The weather in this case was in a

state of almost constant change while the sun popped in and out of fast moving clouds. The relatively smooth surface of this lovely paper (Canson Mi-Teintes, 160 gsm/75lb) made pushing the powdery colour around quite easy, making it sympathetic to rapidly changing conditions.

With scattered cloud like this, the sun often acts like a spotlight picking out such things as the warm red ochre cliff. When the light areas are warm, as here, the shadows will invariably become a cool blue or purple as I noticed here on the shadowed areas of beach and cliff.

EXERCISE - CAPTURING A RAPIDLY CHANGING SKY SCENE

Skies of the type in this exercise are constantly moving, exercising your powers of observation if you want to capture them on paper. I have found that the best approach is one that amounts to taking a mental photograph. The secret is to look and study for a period and then, as fast as possible, work from your visual memory. If you use a darkish toned paper for the mid-tones, both light and dark colours can be used for the extremes of contrast.

This picture was made on one of those turbulent days in early spring when strong winds dramatically alter the cloud formations. I knew I would have to work quickly in order to keep up with the atmospheric changes.

COLOURS
• Landscape starter box, see p.8

PAPER
• Canson Mi-Teintes dark buff pastel paper, 160gsm/75lb

BEACH HUTS, STAGE 1

Stage one

A low horizon was chosen deliberately because this would give me maximum potential to develop the stormy sky. There was very little that needed to be drawn precisely at this point, although the placing of the beach huts needed careful consideration, as did the wigwam which stood out like a beacon in the sharp sunlight. The drawing was made in charcoal, and because the sky was so important I also indicated where the mass distribution of light and dark should be.

Stage two

I scrubbed in the initial colours of the sky and blended immediately with the fingers. The pastels used for the sky were olive green (tint 6), raw umber (tint 1), charcoal grey-grey green (tint 2) and light brown. Ultramarine (tint 1) and cœruleum (tint 2) were used for the blues. It is interesting to see how quickly a picture can begin to take shape when this form of blending is used.

Stage three

I added more colour and definition to both the landscape and sky. The individual cloud shapes are given more form and separate colour. Use raw umber (tint 8) for the high-lighted cloud tops and add purple (tint 5) to the lower sky area.

Finished picture

The finished picture comes together in little more than 40 minutes. The texture of the Canson paper is left well in evidence which enhances the swiftly applied pastel. Notice the radical difference in the deep blue sky at the top of the picture and the pale, watery blue at the horizon. Although one reads how blue lightens towards the horizon, this somewhat exaggerated effect can only work if it is really observed.

To add some foreground texture, the reeds were developed in a downward

hatching technique. A very small amount
of extra definition was given to the huts
with a sharpened black Conté stick.

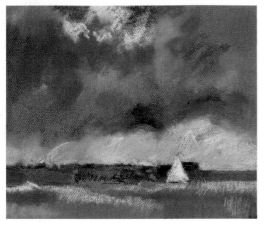

BEACH HUTS, STAGE 2

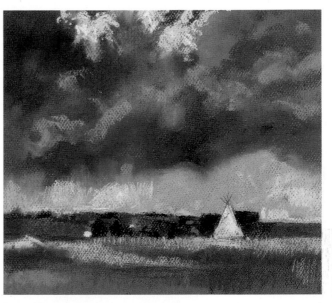

BEACH HUTS, STAGE 3

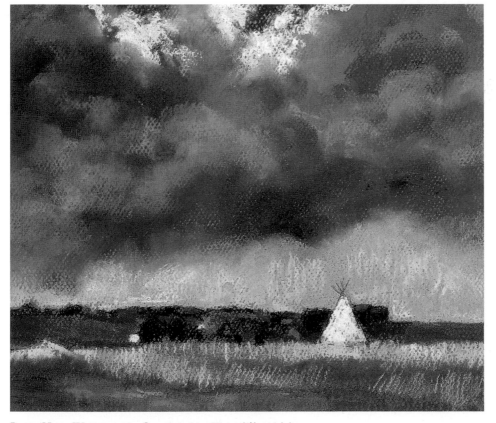

BEACH HUTS, WALBERSWICK, SUFFOLK , 24 x 28 cm (9½ x 11 in)

Trees and Foliage

Trees are one of the most crucial elements of a landscape scene. Up until the time of the artist John Constable, at the end of the eighteenth century, trees in most paintings looked much the same, painted to a formula. He was the first artist to differentiate between elms, oaks and beeches. Today, in paintings we expect to see not standardised trees but particular trees with all their individual colours and shapes.

TIP

Try mixing some other greens:
Bright green – cœruleum blue and lemon yellow
Deep green – ultramarine blue and cadmium yellow
Olive green – cobalt blue and yellow ochre

THE SHAPE OF TREES

Most of the trees that occur in the landscape can be identified by shape alone, with or without foliage. Very often the winter can be a good time to sketch trees when all the leaves have dropped and the structure of the trunk and branches becomes more apparent (see *Jesus College, Cambridge, in Frost*, page 43). When drawing trees with foliage pay careful attention to the way leaves mass on the branches. The shapes or clumps and the density of the foliage will differ from tree to tree.

FOLIAGE

The treatment of foliage depends to a great degree on how far away you are when viewing it. From any sort of distance the main masses or clumps should be sought and treated very much for overall shape, see opposite. If the viewing distance is relatively near then again look for overall shape but it may also be necessary to look at individual leaf shapes. This can be done with a little more attention to design and a more decorative approach, searching for the overall texture and density of the foliage, but taking care not to get bogged down with unnecessary detail.

Mixing greens: the right row shows black with yellow superimposed and, left, ultramarine blue with the same yellows over the top: (top to bottom) cadmium yellow, yellow ochre, lemon yellow.

THE COLOUR OF TREES

The colour of trees will vary according to the time of year. In summer, the range of greens is enormous – from the cool green of willows to the much richer, warmer green of oak. To create foliage greens, mix black with any of the yellows. This has the advantage of producing a neutral type of green. Once a green base colour has been achieved by blending two colours together, it can be hatched over or feathered with another colour to take it towards blue or yellow or whatever colour you want.

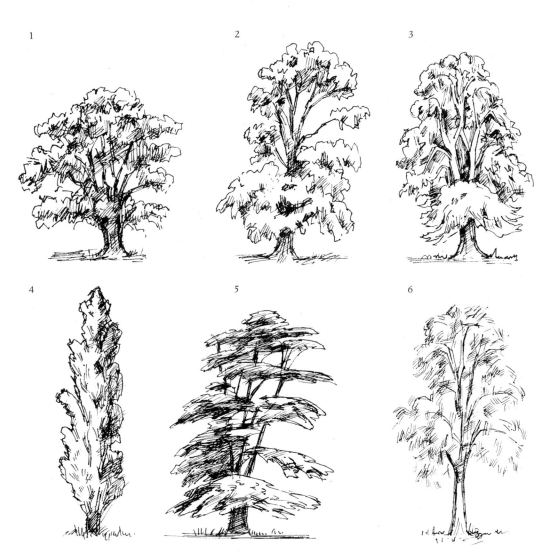

Trees 1 – Oak 2 – Elm 3 – Beech 4 – Lombardy Poplar 5 – Cedar 6 – Ash

A summer willow in full leaf. Note the cool, bluish quality of the green.

WORKING WITH DIFFERENT GREENS

So often when one looks at painted landscapes, insufficient attention has been paid to the different types of green that exist in nature and a sort of standard green takes over. Often the basic difference between them is one of temperature – warm and cool. In this pastel of Granchester Meadows, the difference between the greens of the two trees is strikingly illustrated.

Mixing the variants of green was a considerable exercise in itself. The tree on the left registered as a series of cool greens with a blue bias. These were made with a mixture of blue green and Hooker's green with a little black rubbed in as well. The warmer coloured tree on the right was mixed with olive green, sap green and Vandyke brown.

Granchester Meadows is a famous beauty spot near Cambridge which has breathtaking views all the year round. Certainly in summer, when this pastel was made, the countryside epitomised everyone's idea of the English idyll. As ingredients for landscape, the scene contains everything you could want; a river with reflections, fields racing to meet the hazy blue distance and sturdy English trees. From a compositional standpoint, the two trees were perfect and I liked the way the tractor ruts in the field snaked away into the distance.

The pastel was made through the middle part of the day when the sun was high in the sky, as the shadows indicate. The sky was clear blue, but as artists we know that that does not mean to say we render it without any gradation. There was a perceptible pink haze near the bluish band of trees on the horizon which is typical of a hot sunny day.

GRANCHESTER MEADOWS, 31 x 41 cm (12 x 16 in)

Jesus College, Cambridge, in Frost, 29 x 42 cm (11½ x 16½ in)

The sanded paper used in this piece of work ate up the pastel but at the same time allowed a continuous build-up of colour. In terms of adding and working over previous areas, this paper is excellent and permits the widest technical approach. However, storing the finished work can be a problem and just blowing across the surface can produce huge clouds of dust.

The final picture shows plenty of hatching and cross-hatching over a blended colour base. Because the paper holds the colour so well, the build-up and retention of strokes of colour feels a natural way to work.

WINTER TREES

Winter trees are always difficult because of the multitude of little branches and the feathery effect that these produce. To overcome this in the picture shown, I used a brown Conté stick sharpened to a point and held in a chalk holder. The long winter shadows were achieved by using permanent and Hooker's green, modified with ultramarine. Hatching and cross-hatching were used to mix the colours optically.

This pastel was made on a strikingly frosty winter morning. As with other atmospheric conditions and natural phenomena, such as mist and sunsets, there was a limited amount of time to work before the effect vanished.

Because of the nature of the row of trees running across the picture, the sky and buildings had to be more or less complete before they could be put in. This meant taking care not to overestimate the depth of tone, particularly in the buildings. Great restraint had to be employed to achieve the effect of the shimmering early morning light as the overall tonality of the landscape was barely different from that of the sky. The colour was almost bleached right out of the buildings and the shadows became a pale bluish purple.

Demonstration

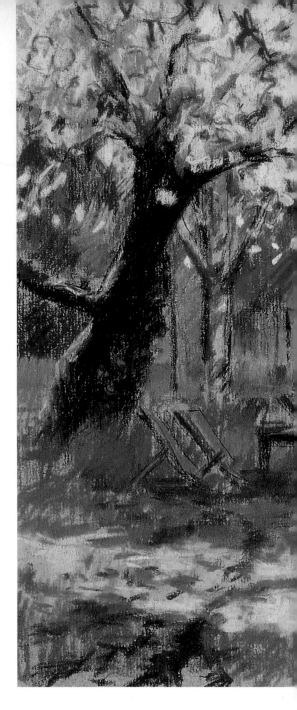

Orchard Scene

The apple orchard which inspired this pastel was made famous by the many eminent people who took tea there – people such as the painter, Augustus John (1878-1961), several of the Bloomsbury set and notable Cambridge characters.

It is not easy to catch blossom in early spring because the weather is often far too inclement. Luckily, on this occasion it was more like summer, with strong shadows cast across the path and the light remaining perfectly consistent for most of the day. The sun moved around, as did the shadows, but the values remained constant. This is by far the most important aspect of working outside – one can cope with shadows moving around slightly, but not wholesale alterations of light and dark.

Blossom is very exciting to paint because where you normally have relatively dark foliage, you are suddenly faced with an area that is very much lighter than everything else. The sufficient aspect here was to make sure that the surrounding tonal values were sufficiently dark to contrast with the lighter blossom.

I had my full selection of pastels to hand but it is surprising how after a while one naturally scales down to working with a few.

COLOURS
- **Reds** - poppy red (6), burnt umber (6,8), madder brown (0,4), crimson lake(0),
- **Blues** - blue grey (6), cobalt (4),
- **Greens** - brilliant green (2, 4,6), green grey, Hooker's green (6,8)
- **Purples** - purple, purple grey(6)

PAPER
- Canson pastel paper, 90 gsm / 42 lb

Method

1 Some careful drawing was needed to get this picture started. The trees were used to create an arch-like effect which would draw the viewer in.

2 With the composition and layout complete, the basic framework of colour was laid down, beginning with sky and working downwards.

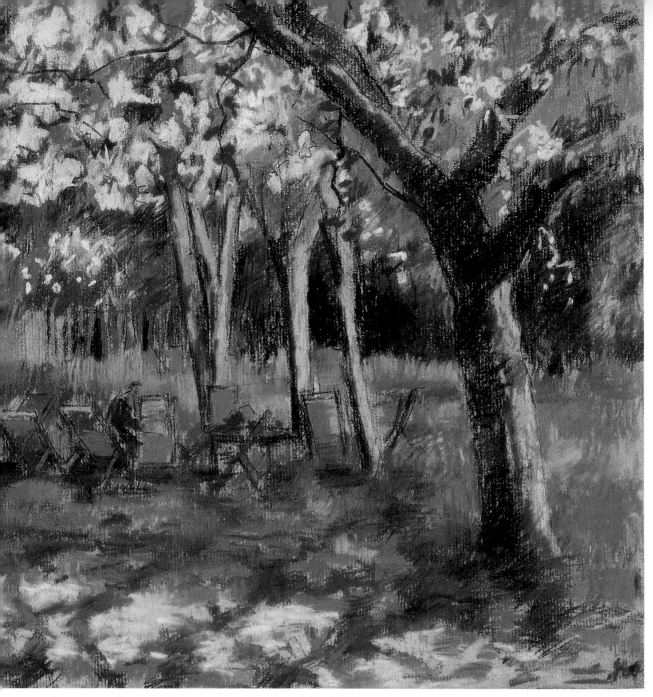

GRANCHESTER ORCHARD, CAMBRIDGESHIRE, 29 x 42 cm (11½ x 16½ in)

3 Because the blossom was very bright in tone, it needed to be placed against a dark backdrop even at this early stage. Even though the paper provided a mid-tone, it was necessary to further darken the trees and bushes in the distance to provide a contrast for the blossom.

4 The shadows on grass and path were brought into focus, taking care with the gradation between light and dark parts.

5 Lastly, crisp highlights were added to the blossom with a sureness of touch which described the shapes of the clusters of blossom. A few last highlights were added to the path and grass in the light areas to balance the composition.

Water

Water and reflections are full of interest and will always bring life to any landscape painting. Of all the elements found in landscape, however, it can be the most tricky to handle. The foremost thing to remember is that water is always parallel to the natural horizon.

One of the greatest problems in dealing with water is that in reflections we have another dimension to cope with. Although the water surface is essentially flat, the reflections come towards you. If water is dead calm then it can appear as a perfect mirror image. Luckily, there are usually slight ripples which distort the reflection and help to emphasise the horizontal nature of the water through directional strokes of colour.

TIP

To capture in pastel the effect of a reflection fragmented by choppy water, recreate the mosaic-like appearance of each piece of colour. Make your marks confident and with distinct edges that have not been smudged or blended. The more ripples in the water, the more broken the colour will be.

TIP

Remember that water finds its own level so marks indicating broken water need to correspond to the horizontal.

COLOUR IN WATER

Essentially water has no real colour of its own but appears coloured depending upon the clarity of the water, the light from the sky and what it is contained by. For instance, swimming pool water appears to be blue, but that is because the pool is painted blue. Pond and river water usually appears murky green because of the mud and vegetation that lies beneath. The sea, however, is largely subject to the condition of the sky, although where it becomes shallow, on the beach for instance, then a sandy colour will prevail. So, all water is a combination of the colours it reflects as well as whatever affects its colour from underneath. It is for this reason that it is constantly changing its appearance.

REFLECTIONS

If you were to place a mirror on the floor and place a vase on it and stand back, the reflection you would see of that vase would be have the same dimensions as the vase itself. Water is exactly the same, so objects like trees and buildings will reflect their exact height. However, this is only true if the water is calm. If there are

ripples, then the image will be fragmented and reflect much farther down the area of water, always assuming that this can be seen.

Remember also that light entering water, or even a mirror, can never reflect back a brighter image so the tones and colours in reflections need to be measurably darker than their image. Reflected images also tend to show slightly darker contrasts and lose some of the half tones.

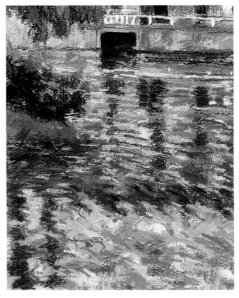

In this pastel detail of water (see page 21), note how the colour is fragmented into horizontal strokes to give the effect of ripples.

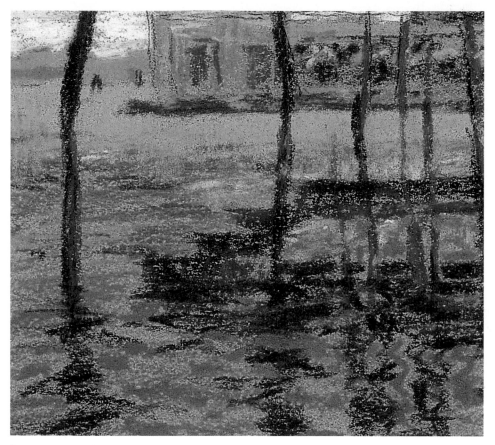

SUNSET OVER THE DOGANA, VENICE

DOGANA, VENICE

Everything in Venice is affected by the presence of water. Many parts of Venice have huge expanses of open water where the light bounces off the surface and also interacts with the equally large areas of sky. So much of what happens in water is a direct result of what is happening in the sky.

In this detail you can see the turquoise effect reflecting on the distant water. This is caused by the blue of the sky mixing with the ever increasing amount of yellow as the sunset deepens. Added to this are the orange and yellow flicks of bright sunlight dancing on the surface of the ripples.

What is important here is not so much the literal aspect of getting the exact colour, because the colours alter so rapidly at this time, but more being able to show how the colour changes from one part of the water to another.

Demonstration

Reflections on water

Water and reflections are always great fun to draw and paint and I find myself constantly returning to them as a subject. Here the build-up of colour was quite carefree, using almost anything that came to hand. It was in the last 10 per cent that more carefully applied colour was used to correlate the reflection to the building, boats and harbour line.

At least half of this picture is water, but for me the challenge was to create an almost abstract network of colour in the form of reflections, in contrast with the more formal approach needed for architecture.

If you have ever visited the Mediterranean or southern Italy you will know just how blue the sky can be. For this sky I found myself searching for the very deepest blues in the box (Prussian blue and ultramarine). When the sky is this blue you will notice that it gradates quite noticeably from the horizon through to a much deeper blue at the top.

COLOURS
- **Reds** - autumn brown (8), madder brown (0,4,6), reddish grey (4,6)
- **Blues** - ultramarine (6,8), blue grey (6,8), cobalt (4,6), blue green, (4)
- **Yellows** - yellow ochre (0,2)
- **Greens** - Hooker's green (3)
- **Purple** - purple

PAPER
- Ingres bottle green pastel paper, 90 gsm / 42 lb

Method

1 A good drawing was needed to start off this picture, taking great care to get the perspective and the architectural proportions right. The drawing was done with black Conté stick, sharpened to a point.

2 Once the drawing was complete, the adding of colour to the building was fairly straightforward using the lightest tints of yellow ochre and reddish purple.

3 With the buildings laid in, it became important to know the value of the sky colour in order to judge the values of the rest of the picture. The gradation was made with both tints of ultramarine and cobalt with a touch of Hooker's green for the turquoise in the lower sky.

4 Because the whole of the lower half of this picture is water, it was important to get the upper half established so that it would then not only be possible to plot where the reflections went but also judge their colours and tones.

5 The water was built up with a series of roughly horizontal pieces of colour to imitate the ripple and wave effect. This contrasts with the method used on the buildings which needed to portray a flatter, smoother surface.

MOLFETTA, APUGLIA, ITALY,
46 x 31 cm (18 x 12 in)

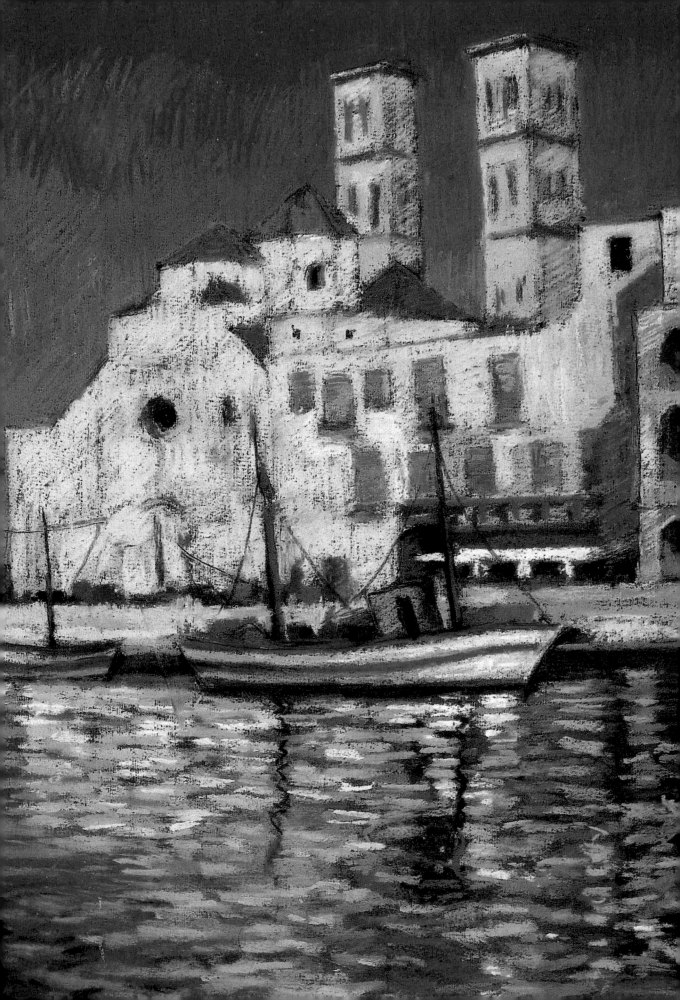

Buildings

Buildings come in all shapes and sizes and are continually fascinating both as an independent subject or as part of a landscape. But buildings have a further dimension in that they involve people as the places in which they live and work. Most buildings are symmetrical in shape and this brings into play the question of perspective. A basic knowledge of the effect of vanishing points and eye level is always a help when drawing buildings. In theory it is quite possible to make accurate drawings without any knowledge of perspective – just by good observation. However, the more knowledge you have, the better equipped you will be, and to know even a little about perspective can help prevent a panic attack when faced with complicated constructions.

TIP

A few simple checks in the early stages when drawing buildings can save a great deal of trouble later on. By sliding your thumb up and down a pencil held at arm's length, with one eye shut, you can see, for example, how many times a doorway goes into the height of a building.

BASIC PERSPECTIVE

With regular-sided objects, parallel walls or sides will recede to the same vanishing point on the horizon. The horizon is determined by your own eye level. The general rule is that receding parallel lines below eye level will travel upwards to meet the horizon, and above eye level will travel downwards. Any that occur directly at eye level will appear horizontal regardless of the angle at which they are seen.

PROPORTION AND SCALE

Proportion is particularly important when drawing and painting buildings. It is not only the proportions within the building itself, as the architect designed it, such as the proportions of the door to the windows, but also how one building relates to another.

It is also important to set the scale of the building relative to its surroundings. The scale of buildings can vary enormously, from dwarfed farmhouses nestling into a French hillside to the monumental classical buildings of Rome.

TEXTURE

The materials used for a building are an important part of their character. Putting across these various materials – pitted stone or weathered brick – will involve ingenuity. The amount of texture visible will be determined by the quality of light. A flat, all-round light will show very little in the way of surface texture whereas a raking light will increase it dramatically (see *The Arch of Constantine* on page 57).

With surfaces such as stone, brick or plaster, a textured surface on the paper is always useful because, if a pastel is laid on its side and dragged across the paper, a textured mark results. If this is fixed, the procedure can be repeated two or three times using slightly different colours. The result is a subtle build-up of texture, as can be seen in *Molfetta* on page 49.

Smoother surfaces such as glass and ceramics can be achieved by careful blending with fingers or torchon with the addition of sharp-edged highlights made with the sharpened edge of a pastel stick. See *Still Life with Stripes* on page 81.

COMPLEX ARCHITECTURE

Very often a complicated piece of architecture will appear less so if you change your viewpoint. Because we are dealing with the problems of a three-dimensional subject, recorded on a two-dimensional surface, what may appear confusing from one angle, from another will disappear. Walk around a building and explore your subject from other viewpoints before deciding on the best, much as a sculptor would with a sitter.

It is always valuable to make extra drawings of a subject, particularly from different angles. This drawing in Conté shows a view a little farther round to the right from where I eventually did the pastel (see page 55). In this case, not only did the drawing increase my understanding of how the buildings grouped together, but I liked the compositional layout so much I was inspired to go on and paint it fully.

I find drawings like this one very stimulating to do because they allow you to focus on those aspects which can easily become overshadowed when you are preoccupied with colour.

FARMHOUSE, LES PLANES (SKETCH), 25 x 39 cm (10 x 15½ in)

ROME ROOFTOPS FROM THE CAMPIDOGLIO

Just like people, buildings have character, and if it were possible to arrive instantly in another country, you would always have a good idea of where you were because of the nature of the buildings. These rooftops have to be in Italy.

This piece of work combines two rather different methods of approach. First there was the careful drawing of the rooftops made with a sharpened Conté stick and begun well before the sun began to set. Drawing this sort of perspectival, architectural view is demanding but it must be got right or it will let down the whole work. The second stage involved the speedy application of colour for spectacular evening sunset. Although the drawing was made in advance of the sunset, the colours had to wait for the tonal balance to be right – once the light started to fail. When this happened work had to speed up dramatically to capture the moment.

Some smudging was used initially to get colour moving around, but eventually a hatching technique was used to mix the colours optically. There was a vast range of colours in the sky, contrasting dramatically with the more sober buildings. Although the buildings took so long to draw, in the end they were played right down so that the focus was on the sky. It could be compared to the relationship between a choir and a soloist: the soloist can only shine if the supporting players are up to scratch.

ROME ROOFTOPS FROM THE CAMPIDOGLIO,
24 x 32 cm (9½ x 12½ in)

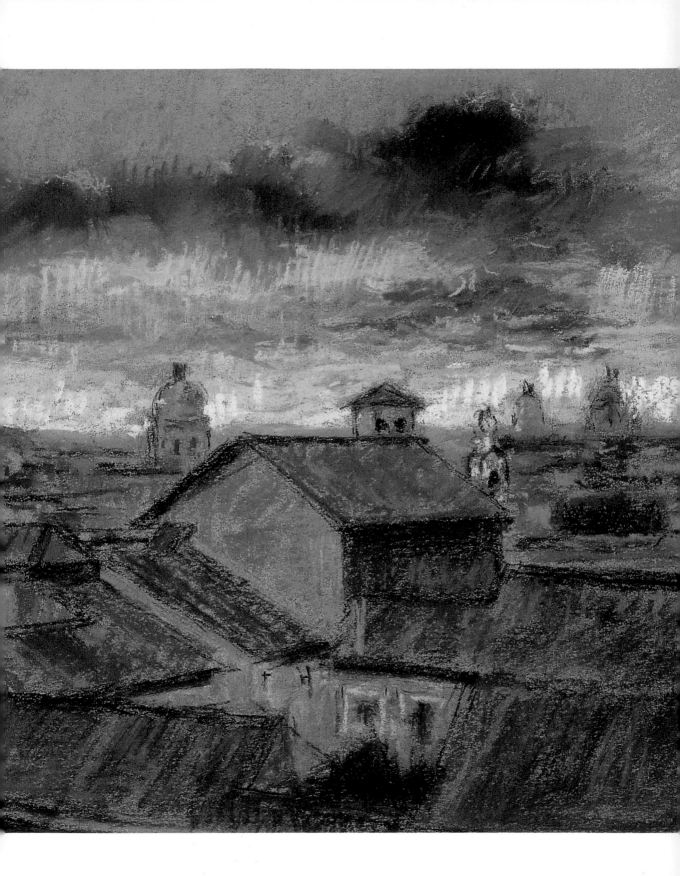

Demonstration

Developing an architectural composition

What attracted me to this subject was the interplay of angles and lines which seemed to speak of structure. To be over-aware of perspective could be just as detrimental to the success of such a piece of work as ignoring it. Obviously a balance has to be struck. In this pastel I was keen to explore the dynamics of the juxtaposing angles, not just of the buildings but also features like the trees and telegraph pole.

STAGE 1

COLOURS
- **Reds** - poppy red (4 and 6), Vandyke brown (6), vermilion (2 and 4)
- **Blues** - ultramarine blue (6 and 8), blue green (4), cobalt blue(2 and 4)
- **Yellows** - yellow ochre (0), lemon yellow (0)
- **Greens** - brilliant green (2 and 3)
- **Purple** - purple grey (6)

PAPER
- Canson Mi-Teintes green/grey pastel paper, 160 gsm/75 lb

Method

1 I felt it important to make a sturdy drawing, covering all aspects of composition and perspective before attempting any colour. With this sort of subject, time spent on resolving these issues will certainly pay dividends later on.

2 I always feel it is essential to establish, as soon as possible, a general feeling of the distribution of colour. Here, the pastels were simplified into groups and applied with very little blending. It is at this stage that one becomes particularly aware of the role that the colour of the paper plays in holding these initial statements together. Notice also how the direction of the hatched marks varies and enhances the sense of structure.

3 The colour was applied evenly and all areas were developed more or less simultaneously. Skies always give plenty of scope for developing artistic preferences. For me, a blue sky is never just one blue. I like to seek a variety of colours that will work as a whole when seen from a distance, but at the same time maintain an exciting surface texture.

The colours of the buildings are more established at this stage, particularly the relationship between the shadowy and the lighter areas. Because of the red and orange tiled roofs, the grey and purple nature of the shadows is naturally enhanced. The blue of the sky works well as a natural opposite to the orange and yellow-based colour.

Finished picture

The final pastel comes together with a good balance of colour between the sky, buildings and foreground. Throughout this piece I tried to keep the application of pastel as lively as possible, using hatching and cross-hatching techniques to create as interesting a surface texture as possible.

STAGE 2

STAGE 3

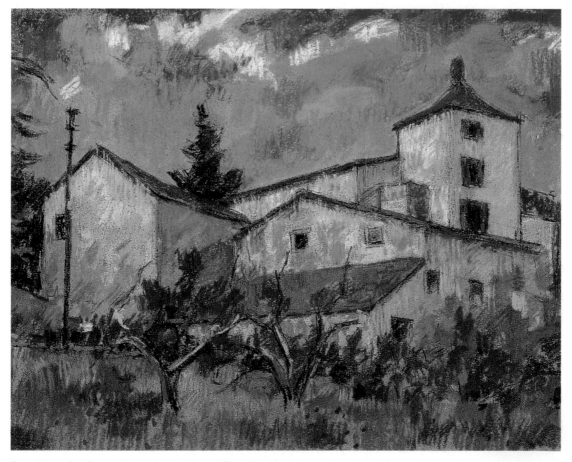

FARMHOUSE, LES PLANES (PASTEL), 24 x 32 cm (9½ x 12½ in)

MONUMENTAL SUBJECTS

This magnificent Roman arch (The Arch of Constantine), which stands just next to the Colosseum in Rome, turned out to be a truly monumental subject. Rome is one of those cities where everywhere you look there is a picture waiting to be created. The combination of the arch and the Colosseum seemed a natural choice but, when I gave it more thought, I decided that the arch alone made a powerful image and that to try and portray both of these major ancient monuments would only detract from each one of them.

The other aspect that caught my imagination was the way the brilliant sunshine raked across the surface creating a wonderful array of different-coloured shadows over the rugged surface. The pale, sand-coloured stone provided the perfect base on which to observe the network of purple, bluish shadows with the same effect that Claude Monet (1840–1926) achieved with his series of Rouen cathedral façades.

1 Anything involving architecture needs to be drawn carefully to avoid the need to make annoying alterations later. In the end I included a part of the neighbouring Colosseum to avoid having to place the arch right in the centre of the paper which would have created a static composition. Because shadows play an important part in this picture, I thought it would be useful to indicate, very broadly, where they occur.

2 This particular Ingres paper had a very fine tooth, so the colour went on quite easily and was pushed around and blended with the fingers effortlessly. This makes it possible to achieve a broad covering fairly quickly, which establishes the main tones and colour values. Although obviously not finished, the picture contains all the basic ingredients and does not look vastly different to how it will end up.

3 It is now possible to start refining elements such as the architectural details on the arch and also the fall of the shadows. In addition, the actual application of pastel starts to become more varied compared with the previous stage where the strokes were more uni-directional.

4 Development continues fairly evenly across the whole scene, although the Colosseum on the right has a little more work added. It was at this point that I decided to fix the pastel because the colour was becoming more difficult to apply and was affecting the underlay. This is a feature of thinner and less textured paper where the surface becomes saturated quite quickly. Intermediate fixing is quite an acceptable process and gives the surface a keen bite which is very pleasurable to work over. This can be done virtually as many times as required.

Once again the development is fairly consistent all over with the view through the central part of the arch being tightened up considerably. The network of colour on the stone face has also become more subtle and sophisticated. Because the subject is pushed right up into the foreground, this picture provides a chance to become involved with pure colour and texture with a minimum of literal description. In other words, it is an excuse to enjoy the advantages of the medium without continual attention to descriptive drawing.

ARCH OF CONSTANTINE, 32 x 23 cm (12½ x 9 in)

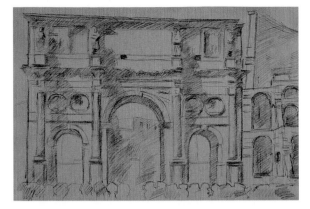

STAGE 1

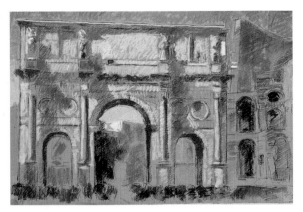

STAGE 2

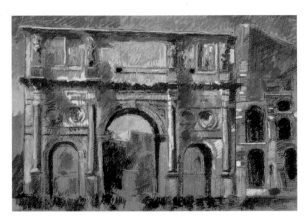

STAGE 3

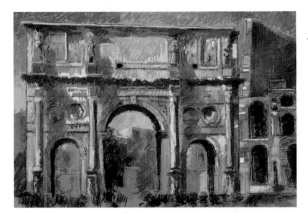

STAGE 4

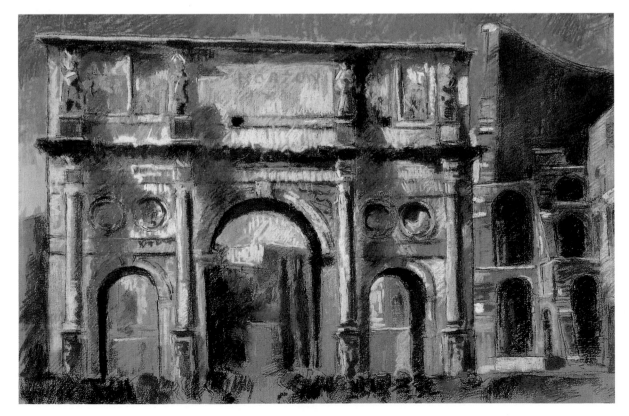

Portraits

The art of portraiture certainly goes back as far as Western art itself and the desire to record somebody's likeness is still as strong today as it was hundreds of years ago. Faces are something we see every day of our lives and they provide continual fascination for the artist. It is not only the desire to record a likeness that drives us but the hope that we may achieve something of a more in-depth view of a person's character. However, before one begins to grapple with such an elusive notion, certain fundamentals about painting portraits need to be established.

TIP

Never underestimate the importance of hair in portraiture. Look carefully at hair styles. Think of how cartoonists can conjure up a personality with just a hair shape.

TIP

Flesh colours are better on a toned paper which is roughly their complementary. For pink skin, green or neutral grey both provide a good base. Flesh tones tend not to show at all well on pink, red or brown grounds.

Drawing is an activity that underpins everything we do as objective artists and although colour always plays a major part with pastels, one never strays far from the art of drawing. In portraiture every tiny observation is important and one can never assume anything. When you think of how similar all heads are in shape and form, it is amazing how different we all turn out to be.

Remember that hair plays a vital role in achieving a likeness. Very often over-concentration on the features will result in an underestimation of the amount and style of hair. Always look at the way people use their faces; the amount they smile or frown – the signs are always there in the form of wrinkles or lines. Skin texture differs widely between different individuals, particularly young and old.

COLOURS

It is very dangerous to give prescriptions for flesh tones, as all situations will be different. Even the two boys on page 64 have different flesh colours as brothers. With pastels, you must search freshly each time and combine colours as you see them relative to each individual. However, it is good to learn how to handle a limited number of colours and through experience

The basic proportions of the head, you will find, differ from person to person. Observing these differences will help you capture a good likeness.

find out what they do. To that end the specially selected box of 12 colours (see page 8) used here for several of the portraits was ideal.

ERIC TRING, 32 x 24 cm (12½ x 9½ in)

POSITIVE HIGHLIGHTS

For this portrait I chose a neutral grey shade to work on. This showed up the predominantly warm flesh tones very well in both the light and dark areas. It also showed up well against the white hair. Although I made a preliminary drawing in charcoal, I was careful not to pursue this too far. If too precise a drawing is made initially it can inhibit the application of colour.

It is essential that the spirit of discovery still exists and, most important, that the constructive process continues with various arrangements of skin colours. Notice how the highlights on the flesh are a positive colour and not bleached out to near-white as can so often happen. This is where the correct value of shadow and half-tones becomes essential to prevent an extreme high-key look.

What was particularly useful in this subject was the mass of white hair: it was a constant reminder that flesh tones are positive colours and seldom become white.

The colours used in this portrait were identical to those in the pre-selected portrait box (see page 8).

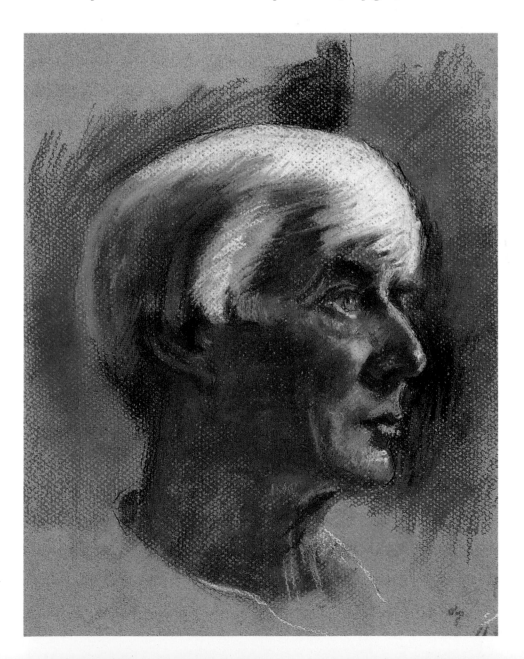

EXERCISE – A PORTRAIT IN STAGES

For this relatively straightforward portrait I used the pastel box specially selected for portraits (see page 8). When I say straightforward, this means that there are no strident or difficult local colours, only typical flesh colour and a white shirt. The colours contained in this box are perfectly adequate to cope with the skin tones of just about anyone and the only problems you might encounter would be if there was some very particular strong local colour in the set-up.

COLOURS
- As in Portrait box

PAPER
- Buff-grey Canson Mi-Teintes, 160 gsm/75 lb

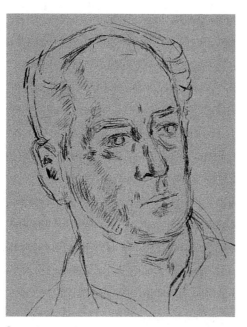

STAGE 1

Stage one
As with other subjects of this sort, I began with a careful drawing in charcoal.

Although I firmly believe that one should construct with colour, I also feel that with pastel it is important to achieve a solid drawing that will provide guidelines for the application of colour. If the colour is laid on freshly and succinctly this also helps prevent the surface from becoming tired and overworked.

Stage two
The first few colours were laid on with strokes and with very little finger blending. Even though the head has a fairly rough-cut appearance, the basic shape and form starts to emerge quite quickly. What is important to establish at this point is the tonal range to be used and how that relates to the colour. Just a few strokes of white on the shirt are enough to help ascertain the strength of colour and tone on the forehead and cheeks.

Stage three
Once a basic structure had been achieved, it was necessary to start to establish the eyes. Very often inexperienced artists will leave important features like this until last. This is not a good idea because trying to fit something into a well-established area will often not work. Much better that eyes, noses and mouths should grow with the general structure. The build-up of hatched strokes is now becoming more and more firmly integrated, with interesting juxtapositions between areas.

Stage four
With a well-developed range of flesh tones it is now possible to start considering highlights such as those on the forehead. This actually qualifies the build-up of colour which, if the values are correct, will provide the right base for a highlight. The lower area of the face is also brought into focus a little more, with the mouth and chin taking on more character. The ruddy colour on the cheek is now brought to more or less its final pitch.

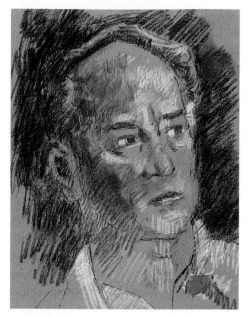

STAGE 2

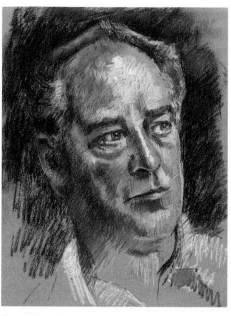

STAGE 4

STAGE 3

Finished picture

The final stage does not show any obvious progress from the previous one, but subtle developments have taken place to bring the portrait to a conclusion. A small amount of blending with the little finger was done without adding any more colour but just by gently nudging into place what was already there. However, some extra colour was applied down the shadow side of the face and background.

RON PEARCE, 31 x 24 cm (12 x 9½ in)

LIGHTING FOR A PORTRAIT

Lighting for a portrait can play an important role. For this portrait I chose to place the model so that only the very edge of the profile caught the light. This meant that a very great deal of the head was in shadow and the highlights appeared almost like a halo around the perimeter of the head.

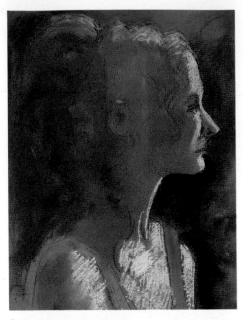

STAGE 2

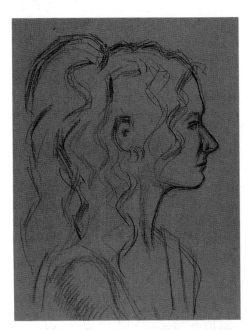

STAGE 1

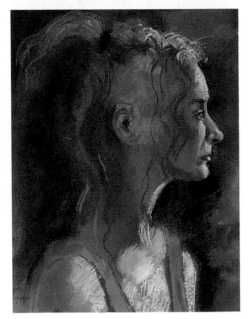

STAGE 3

1 With a drawing, I first established the general proportions and positionings of my sitter before becoming involved with colour. In this I found it essential to place the ear and gauge the overall width of the head. This latter aspect was surprisingly easy to underestimate and needed two or three attempts to get it right.

2 I used relatively few pastel colours to begin with but blended continuously with my fingers to get a good base covering. The hair colour needed very little modification and I found myself using the brightest unmodified reds I had in the box.

3 The balance between light and dark becomes more defined here. Notice the warm shadows on the neck and face as compared with the grey, cooler shaved head area. A small amount of definition around the eye and a highlight on the lip suddenly bring things into focus and give the portrait a much greater sense of presence.

Finished picture

Finally the hair is broken down into several versions of red, brownish red and warm and cool versions of a highlight pink. The hair plays a major role in this portrait so a good deal of care and attention is needed to make it work. Sharp highlights are also added, as a last touch, to the earrings. There was no intermediate fixing in this pastel and the texture of the paper was quite sufficient to support the layers used.

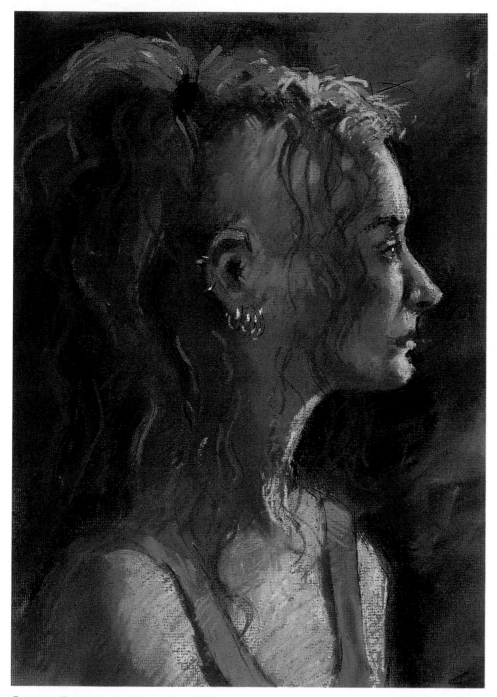

GIRL WITH RED HAIR, 30 x 24 cm (12 x 9½ in)

CHILDREN AND YOUNG PEOPLE

Young people are especially difficult to draw because their faces are far smoother than those of older people and therefore do not contain the same superficial characteristics. However, it is a mistake to assume that children have less character; it is there, but you must search for it.

Drawing children is always a challenge because they never keep still. Therefore you have to take a somewhat different line with them than with an adult who will pose more reliably. Rather than trying to draw a piece at a time whilst looking up regularly, with children it is better to take a long hard look and try to work more from your immediate visual memory. If possible, try to draw children when they are unaware of you so they will be less self-conscious. Keeping a sketchbook for these sorts of moments is absolutely essential.

PRELIMINARY SKETCHES

Before starting on any type of portrait it is advisable to make preliminary drawings to explore your sitter's character and also compositional possibilities. Having decided to do a double portrait of the boys in their hats, I thought it best to investigate their relationship on the page. This drawing (top) in Conté looks at a three-quarter profile.

Children are always smiling but it is very difficult to record this naturally. I feel the smile is better represented by the camera where the instant time framework is much more suited than is a drawing or painting to the freezing of a moment in time. Nonetheless, I attempted in this drawing (above right) to try and introduce a smile because it has such a lovely effect on the shape of their cheeks!

This drawing (right) was made with very soft charcoal using the fingers repeatedly to smudge and blend. With faces as young as

TIP

Children are natural posers, either consciously or unconsciously, so it is always worthwhile having a sketchbook to hand to catch a fleeting moment or gesture. It need only be a few lines but it can record the essence of a moment to which you can later refer.

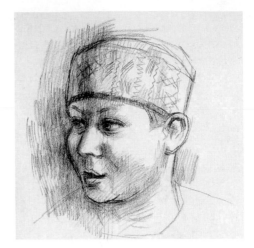

JOSH, 32 x 23 cm (12½ x 9 in)

JOSH AND TOBY HORTON, 42 x 31 cm (16½ x 12 in)

TOBY, 32 x 23 cm (12½ x 9 in)

this, modelling must be kept broad and simple as overworking can lead you to make your subjects look older than they are. It is important to look carefully at the overall shape of the face and the distance between the eyes, nose and mouth. The drawing was done on blue/grey pastel paper with charcoal, Conté and white chalk for the highlights.

Double portrait

Although this was to be a double portrait, I wanted to present the boys without any allusions to background and to keep the placing as simple as possible. The composition worked well in the sketch (opposite), I feel, but the final presentation works just a little better. It seemed to work naturally, connecting the two by having the younger boy turning his eyes, almost as if he were trying to see what his older brother was up to.

My initial thoughts at the outset of this double portrait of my sons was that I had made a mistake in using the strongly textured side of the paper because it seemed to be interfering with the skin tones. However, once well into it I was grateful for the surface texture as it helped to prevent the work from becoming clogged up with too much pastel.

As with any picture of children, there is a sense of hitting a moving target and strength of perception and quality of observation are taxed to the limit. Although the boys were drawn individually I still had to be careful to seek out differences. The whole point of a double portrait is to explore the individual nature of each person as well as any likenesses.

Josh and Toby Horton, 24 x 33 cm (9½ x 12½ in)

The Figure

Since the very beginning, the figure, in particular the nude, has occupied a central place in Western art. We are surrounded by people all the time so it is not surprising that we turn to them for subject matter. You can sketch a figure on the bus or on the beach, learning how to capture a pose in a few strokes. In my case I have always enjoyed drawing my children and domestic scenes. These are subjects that are readily to hand and of which I have intimate knowledge; I find myself returning to them again and again. Pastels are perfect for figure studies and particularly suitable for capturing the translucent quality of skin.

LIFE CLASSES

Many artists, of all disciplines, attend life classes or form a group of their own with a life model. If you have access to any such groups where you live, I would strongly urge you to join. Drawing the human form is one of the most pleasurable and demanding activities I know of. It is stimulating and at the same time feeds back into all other areas of artistic endeavour. If you are going to include people into your pictures then it follows that it pays to be able to understand how they are constructed. Even if you never paint people, the intellectual effort needed to draw from life greatly sharpens your senses for all other subject matters.

KEEPING A SKETCHBOOK

It is always sensible and practical to choose subjects that are familiar to you because this will help you in the judgements that you make. One of the secrets of drawing people is always to keep a sketchbook with you so that a rapid drawing can be made when you see someone doing something worth recording, or you are just taking a short break. Many artists sketch people involved in day-to-day activities and build up a library of images that they can use at a later date for painting.

Many paintings come into existence as a result of sketchbook drawings which are taken from first-hand observation from life. Both the pastels *Josh's Camp* (opposite) and *Boy with Candle* (pages 25–7) were born from repeated observation of children. By drawing the same person several times you can build up a firm picture of their characteristic posture and also the way that they move.

FIGURES IN LANDSCAPES

You may find it difficult to place figures in a landscape or townscape whilst actually working on the spot. Their presence is so fleeting that only the swiftest eye and sharpest visual memory can cope. Adding figures at a later stage is a much easier thing to do. To simplify matters, make a note of your eye level within your picture and also of whether you were standing or sitting. If you were standing, the height of the people will be consistently the same across the eye line, making obvious allowances for differing height. If you were sitting then the eye line will appear approximately through people's waists regardless of where they are in the picture.

REWORKING A PICTURE

Often a picture just does not seem to be working out. Sometimes it is better just to abandon it and start again, but there are ways of rescuing pictures if you persevere. This pastel, *Josh's Camp*, went through many stages, some of them with me in despair, before reaching the final stage.

Initially, I had great trouble separating the colour of the boy's skin from that of the surrounding sand. Then the sky seemed to have become uncommonly dark considering it was a sunny day. In addition, rightly or wrongly, I used a lightweight paper which very soon became saturated with all the overworking. When this happens there is simply too much pastel pigment on the surface and so intermediate fixing becomes necessary. This I did with a diffuser and bottle of fixative made by a reputable company.

However, this was where disaster struck because the whole picture darkened dramatically – along with my spirits.

The choice was either to abandon the picture and start again or persevere. Eventually, after much reworking, the picture came around and I am very glad that I did not give up. Curiously enough, it seemed to gain a strength that pictures often do when they have had that amount of effort put into them, and from a technical point of view the surface of the pastel acquired an interesting texture as a result of hatching and cross-hatching.

Very often I find students too eager to give up; the lesson to be learnt here is that there is always something to salvage and to work at. It can be just as tough for the experienced as for others.

JOSH'S CAMP, 31 x 46 cm (12 x 18 in)

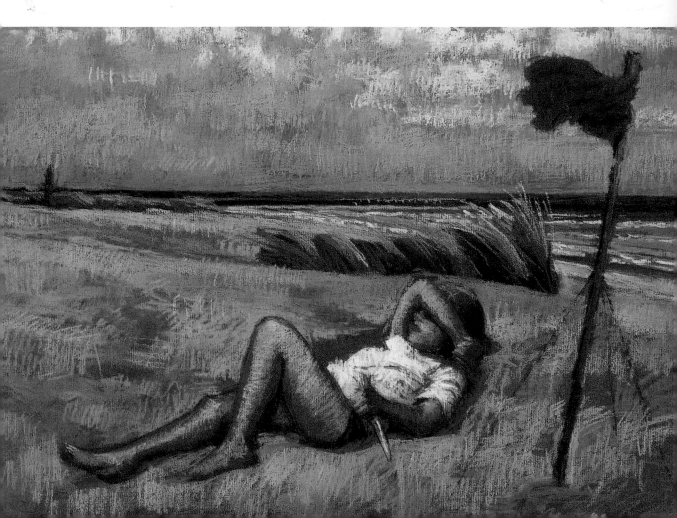

FIGURES IN THE URBAN ENVIRONMENT

I had always wanted to go to the Venice Carnival, which takes place every February. So one year I did, armed with a small watercolour box and several sketchbooks. These characters posed for me for some time whilst I made watercolour drawings of them which on my return home I worked up in pastel.

Although standing against the magnificent background of St Mark's Square, I reduced the architecture to a minimum because for me the real attraction was the bright but low winter sun that cast long shadows everywhere.

In the pastel painting, the preparation of the paper was important because it played a key role in the finished effect. I applied a pale blue, irregular watercolour wash which I flicked on in parts with a stiff brush. Then, in pastel, I used several ready-made greys, such as cool grey and blue grey, for the background. The shadows were made up from indigo, mauve and ultramarine and the figures contained the usual combination of reds and yellows with charcoal grey for the dark areas.

This was an ideal subject for pastel because of the nature of the local colour in the costumes. Unlike other subjects, where you might need to be more precise, here there was reasonable licence to use whatever colours were available in the box.

CARNIVAL CHARACTERS, VENICE, 38 x 56 cm (15 x 22 in)

PORTIA RECLINING, 23 x 31 cm (9 x 12 in)

FIGURES IN THE INTERIOR

This pastel began as a fairly
straightforward drawing from life but, as
often happens, I thought it would be
interesting to take it further by adding
colour. During the Renaissance, the female
nude was often portrayed very simply as
an almost unmodelled pale shape but
brought to life by her surroundings. This is
what I decided to aim for here by using
strong colours in the draperies and on the
sofa. These were pansy violet (5,7), with
the decoration added in ultramarine blue
(5) and crimson lake (4). The cockatoo
drape was made with Hooker's green (3,8)
for the leaves, while the bird was made
with cadmium yellow and crimson lake.

The colours of the figure were very
similar in tone and there was just a small
difference in hue as it was important not
to make any jumpy transitions. Cadmium

orange (1) and lemon yellow (0) were used
for the bulk of the body in a gently
hatching method, and pansy violet (1) was
used for the breasts which came over as a
cooler pink, not having been exposed to
the sun.

Fundamentally though, the real interest
in this subject lies in the fact that the body
is engulfed by sumptuous colours provided
by the fabrics and cushions. The treatment
of the figure is still relatively simple and
brought to life more by what is
surrounding it, rather than any intrinsic
value it may have in itself.

FIGURES BY CANDLELIGHT

Candlelit subjects are intriguing because of the magic and mystery of the deep shadows contrasted with the relatively small, brightly lit area close to the flame, with its jewel-like highlights.

Candlelight also does very interesting things to colours. As you would expect, everything takes on a warm glow which is down to the yellow quality of the light. Because of the relatively low power of candlelight, colours of any description can only really be identified fairly close to the source of light. The farther away from the flame, the more monochromatic everything is.

I made this study half way through a meal on a balcony in Tuscany. I needed a small table lamp to be able to see what I was doing and the whole thing was completed within the space of 40 minutes.

Working on a subject like this makes one more aware of tone rather than colour. The paper was the darkest sheet in the pad – a deep blue-grey – which is left showing through in the incomplete areas. A very small range of colours was used and I concentrated on the dramatic contrast between the sharp, warm highlights around the candle and the acres of shadow and gloom.

Curiously enough, it does not matter a great deal what colours occur in the shadow areas as long as the tonal structure is good whereas the highlighted areas need to be warm, clean, crisp and succinct.

CANDLELIT SUPPER, TUSCANY,
31 x 46 cm (12 x 18 in)

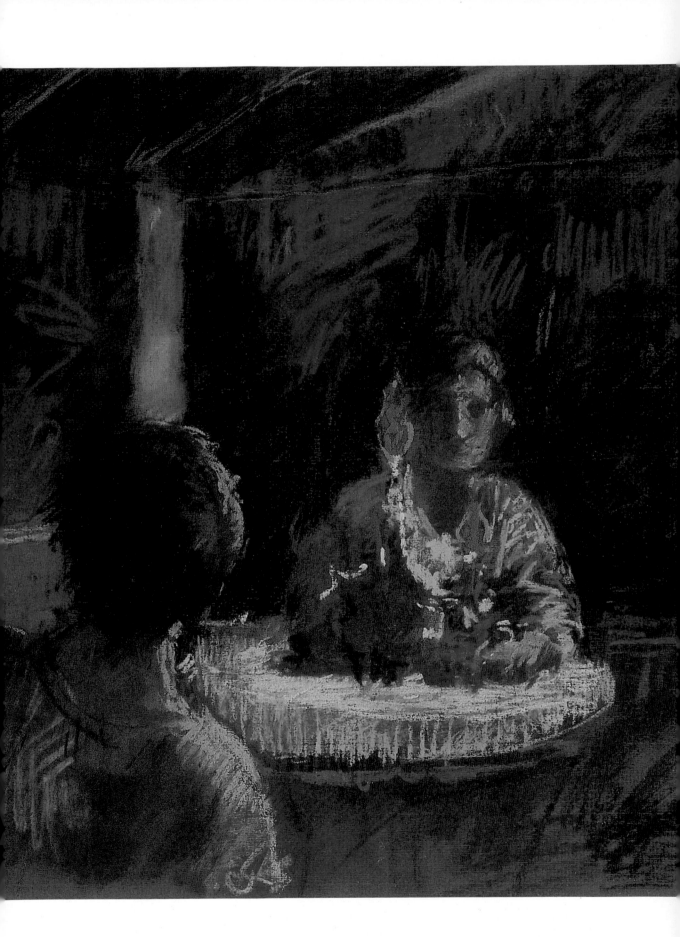

Demonstration

Pastel wash underpainting

This pastel has several interesting features which make it rather different in both method and interpretation to most of the others in the book. First, an underpainting is created by washing the initial application of pastel colour with water. This is allowed to dry and then pastels are worked over the top. Second, the subject is seen *contre jour*, which means against the light source. This creates interesting effects and results in the main subject often being seen as little more than a silhouette with light creeping around the edges. Finally, because of the space restrictions within the bathroom, it was not possible to get very far back from the figure. This has produced its own strong effect, that of looking down on the subject, which puts across the feeling of a very particular and rather confined space.

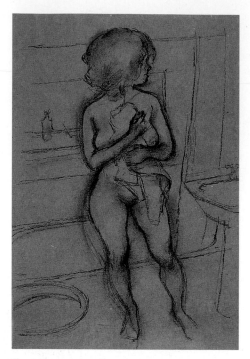

STAGE 1

COLOURS
- **Reds** - poppy red (6,8), madder brown (0,6,8), burnt sienna (0,4), crimson lake (0)
- **Blues** - ultramarine blue (6,8), blue grey (4,8), blue green (1,3)
- **Yellow** - cadmium yellow (4,6)
- **Green** - olive green (6,8)

Method

1 The initial drawing was made with charcoal, using the fingers to rub out where necessary. This is always, for me, a very enjoyable part of the process because I love drawing and am never in a hurry to move on.

2 Here the process begins to differ from other pastels described in this book. Colour was applied with sticks of soft pastel, with no attempt to gradate at this stage. Instead, colour was applied in simple block form corresponding to the local colour observed.

3 Using a brush, with a jar of clean water, the pigment deposited on the surface was then transformed virtually into paint. The pigment dissolves very well in water and can be pushed around quite freely. It is useful to have a piece of tissue or rag to hand during this part of the procedure to take up any excess. In fact the rag can also be used to direct colour, simply by wiping it.

Finished picture

Once the surface was dry, more pastel and chalk was worked over the top to further define and also develop texture. Charcoal was also brought back to sharpen aspects of the drawing. This method of starting a pastel contains wonderful possibilities and can sustain a very flexible approach which is suited to just about any subject matter.

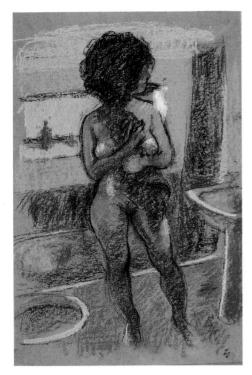

STAGE 2

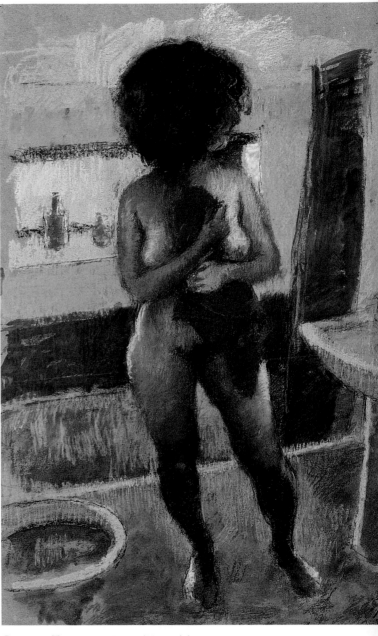

GIRL WITH TOWEL, 56 x 37 cm (22 x 14 in)

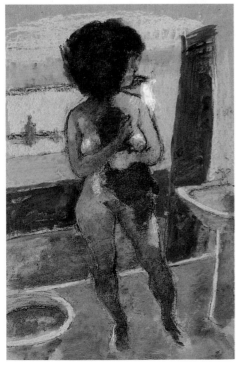

STAGE 3

Still Life

In some respects, one might make the comparison of 'still life' to a string quartet in music. It contains all the vital elements of picture making but without the additional problems of conveying a message, whether it be social, political or emotional. It allows the artist to concentrate purely on the problem of pictorial grammar, just as a composer would with all the elements associated with good composition.

Most artists attempt a still life or two during their career and some make it a substantial part of their working life; look at the work of Chardin (1699–1779) and Cézanne (1839–1906) for example. The most valuable lesson that painting a still life has to teach us is that absolutely anything will make an interesting subject once it is viewed with the detached eye of an objective artist. This is what John Constable meant when he said 'I never saw an ugly thing in my life for light and shade will always make things beautiful.'

CHOOSING A SUBJECT

All of us should be able to put our hands on a collection of objects, however modest or trivial, and make up a group worth painting. Very often we are far too fussy about what we choose to work from, assuming that if the subject is beautiful in its own right, the picture will be beautiful too. This, of course, is not the case and, once you have made the effort to settle down in front of a subject, it is surprising how quickly you become absorbed in it regardless of whether you are painting a star fruit or a potato.

Planning the composition and making sure all the elements are harmonious can also become obsessive without a satisfactory outcome. Try looking for a 'found' still life. This is when you alight on a corner of a room that contains objects that have been naturally placed, in other words, found as they are left. Sometimes the distinction between a 'found' still life and an interior can be blurred.

VARYING YOUR VIEWPOINT

Moving around your still life will give you some quite dramatically different compositions to chose from. These will involve quite different dynamics in terms

TIPS FOR SETTING UP A STILL LIFE

- Vary the height of objects so they occupy different areas of the picture plane.
- Try to vary the shape and texture so the descriptive aspect will be interesting for you to paint.
- Be aware of creating distance into the picture space with your objects, through overlapping.
- Place the objects so that you create interesting spaces, or negative shapes, betweeen them.

- Usually it is better to see the group against a backcloth, otherwise the jumble of the rest of the room can be confusing. It also helps you to 'read' the tonal and spatial values more easily.
- Try to achieve a consistent and uniform light source. Daylight is best but, if you have to use artificial light, make sure there are not too many sources which create complex cast shadows.

of perspective, texture and the relationship between objects. These two sketches of the *Still Life with Hat* composition give quite different impressions of the same composition.

The first drawing shows a composition with an upright format. The viewpoint was also taken from one side. The most noticeable aspect of this view is that the objects are too crowded together, but the upright shape suits the subject very well. The reason I chose not to go for this view was not because I felt it did not work well as an idea. On the contrary, I think it would make a very interesting painting. It was more to do with the spacing of the objects which, seen from the front of the table as in the second drawing, gave each component a chance to breathe in an almost frieze-like manner, stretched across the horizontal plane. This was more in keeping with my original thoughts on first seeing the group.

The second drawing was made from the corner, looking at the arrangement from an angle of about 45°. From this viewpoint the objects were spacing out quite nicely. In addition to working out compositional ideas I also began to explore some of the tonal possibilities to gain an idea of the weight of the subject.

Looking at the finished pastel (see over) you can see that, not only did I move around to almost a full horizontal alignment to the table, but that I also stood up. This allowed a better view of what was on the table top and is particularly noticeable in the plate of fruit.

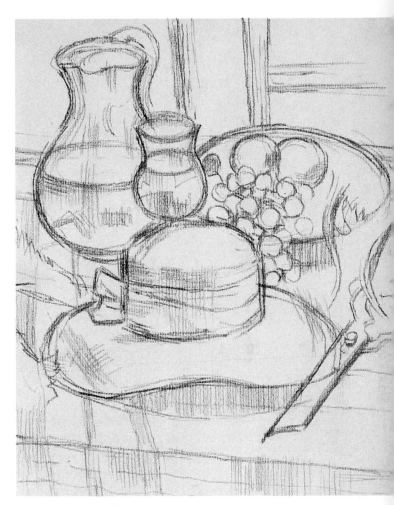

STILL LIFE WITH HAT (PRELIMINARY STUDY 1), 31 x 46 cm (12 x 18 in)

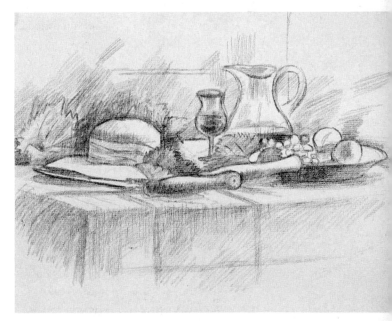

STILL LIFE WITH HAT (PRELIMINARY STUDY 2), 31 x 46 cm (12 x 18 in)

Demonstration

Still Life with Hat

This still life very much encapsulates the time of year in which it was done. It was late summer when the leaves on the vine were beginning to turn and the grapes were ripe. The shears and sun hat are never far away at this time of year, and a jug of wine, of course, is welcome at any time. Although not a true 'found' still life, a similar arrangement could be found on almost any garden table during the late summer. It makes for added interest if the elements within a still life group relate in some way and so look as if they belong together.

COLOURS
- **Reds** - poppy red (4 and 6), rose madder (4), burnt umber (4),
- **Blues** - ultramarine blue (6 and 8), cobalt blue (6), blue green (4),
- **Yellows** - cadmium yellow (4 and 6), yellow ochre, lemon yellow (2, 4 and 6),
- **Greens** - Hooker's green (3 and 5), sap green (5), viridian

PAPER
- Ingres raw sienna pastel paper, 90 gsm / 42 lb

Method

1 Having decided on the elements of the group, I then considered the various angles of approach. After making several sketches, two of which are shown on the previous page, I settled for the view illustrated here.

2 A drawing in charcoal was made outlining the main objects and rough grouping, before proceeding in colour. Because the paper was fairly lightweight and not pronounced in texture, the first layers of colour were blended quickly with the fingers and in some areas, such as the lower portion of the tablecloth and the background, were not really touched again. I always find it interesting when various areas of the same piece of work are treated differently. If a section of a picture is achieving the desired effect, then it is not always necessary to bring everything up to the same level.

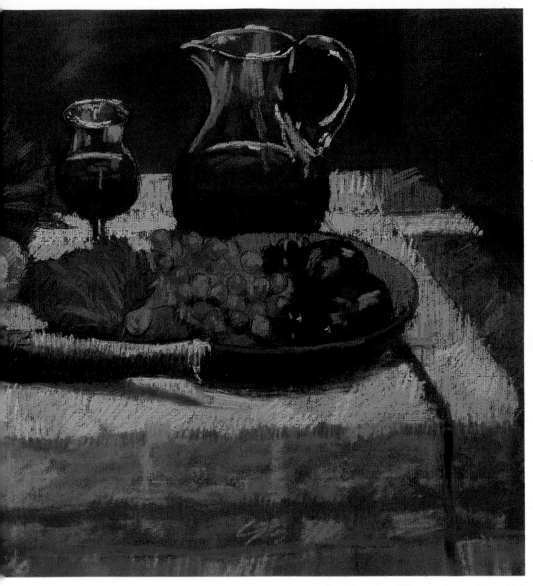

STILL LIFE WITH HAT, 31 x 46 cm (12 x 18 in)

3 With the base colours applied, the next step was to establish the likely final strength of colours such as the red wine and green vine leaves. These are both strong colours and their relationship needs to be sorted out fairly early.

4 At this point I started looking for more delicate, gradated mid-tones in the straw hat and the fruit. Then the final strength of the extremes of contrast was added, such as on the pale blue parts of the tablecloth and highest tones on the hat.

These highlights were then balanced with the dark blue shadow under the brim and the dark green vine leaves.

5 Texture, as always, plays an important role here and I was careful to show the difference between the rough texture of the straw hat, the smooth surface of the highly reflective glass and the dull shine on the grapes. Once again the sharpened Conté stick allowed for finer definitions beyond the capability of the soft pastel.

FLOWER GROUPS

Flowers are amongst the most popular of subjects. There is so much variation in shape, texture and colour, not to mention their intrinsic beauty. There are a few points to watch out for. Unless you are painting in the garden or have found the perfect potplant indoors, do not be tempted to include too many blooms in your composition. A whole bunch straight from the florist can be too busy and may need pruning down to a workable few.

Most flowers are very brightly coloured, almost luminous. Such colours are virtually impossible to match in the ordinary sense. What you need to do is to create an impression of such colours with optical mixing. Try to look for relationships between colours – warm and cool, light and dark, and how one colour appears next to another.

Flowers usually appear best against a fairly uniform background. This does not necessarily mean flat, but a cloth with gentle folds always works well. When choosing a backcloth be careful not to use a colour that might clash violently with something in the set-up, or a tone that is too similar.

EXERCISE - FLOWER STUDY

Flowers are always a joy to work with and are nearly always easy to come by in some shape or form. In this study I kept the ingredients fairly simple and placed the group in a strong side light. Lighting is always important and must be carefully arranged to complement the subject. In this case the side light in combination with a dark background produced marvellous areas of 'lost and found'.

COLOURS
- **Reds** - madder brown (4,6,8), poppy red (2,4), crimson lake (0,2,4), vermilion (4), cadmium red (2,4), burnt umber (4), conté brown,
- **Blue** - Prussian blue (8)
- **Yellow** - lemon yellow (2.4)
- **Greens** - brilliant green (3,4,5), Hooker's green (4, 5, 8)

PAPER
- Ingres pastel paper, 90 gsm / 42 lb

Stage one
Although this is a simple enough bunch of flowers there are enough different types and colours to require careful drawing, defining the areas where colours change. The drawing was made with a fine piece of charcoal which was both flexible and precise.

Stage two
As always, it is a bit of a race to get a broad covering of pastel so that it begins to look like a picture. The background browns were applied with the pastel sticks on their sides to cover the area quickly. It is a good idea to change the direction of the marks for an interlocking effect. The background needed to be established early on because it is essential for gauging the true colour of the flowers.

With bright coloured flowers of this sort, try to keep your colours clean, without overworking them. Consequently, I went straight in and applied the extremes of contrast on the flowers in the light, so that the colour would appear fresh and unworked, benefiting from that 'first time' quality.

In the darker areas such as the green stems and striped pot I was able to use an amalgam of colours blended with the fingers.

Stage three

All the shapes in this picture were in themselves quite simple and quickly established. The final stages consisted mostly of redefining the shapes of petals and some extra clarification of the stems. It was also important to get the shadow colour of the underlayer of petals right because this also helped with the three-dimensional aspect of the flower heads. This was further enhanced by using a sharpened Conté stick to give good, sharp, precise edges.

Although much of the shaded area on the left merges with the shadow and the background I was careful to preserve the gradation of each colour, as a colour and not letting any of them sink into a generally undefined shadow colour. The areas on the right side caught the light and formed very distinct edges for which I used a Conté stick sharpened to a point to achieve precise definition.

Texture always plays an important part when drawing and painting flowers and the structure of the petal layers on the chrysanthemums was a challenge. Here again the Conté stick came in useful.

The background, although plain, can never be dismissed as unimportant. There is actually quite a lot of it in this picture which has to be 'orchestrated' to back up the main subject as well as possible. I used several shades of burnt umber and also a mid-brown Conté stick turned on its side. Careful attention was paid to the edges where the flowers and background met and the tonal relationship that resulted. Texture was also suggested here with a series of hatched and cross-hatched strokes over a finger-blended base colour.

FLOWER STUDY, 42 x 22 cm (16½ x 11½ in)

Demonstration

Still Life with Stripes

The interpretation of the term still life can be wide and varied. The still life illustrated here belongs very firmly to the traditional definition where the elements are carefully arranged into a group that is interesting to paint. Take care not to over-arrange or become too obsessed about the grouping. The real sorting out should be done on paper and not on the subject whilst setting up.

STAGE 1

COLOURS
- **Reds** - madder brown (0,4,8), burnt sienna (0,2),
- **Greens** - Hooker's green (5,7), olive green (6,8),
- **Yellows** - yellow ochre (0,2), lemon yellow (2),
- **Purples** - purple grey (8), pansy violet (2,5,7)
- **Blues** - Prussian blue (8), ultramarine (6,8)

PAPER
- Sanded pastel paper

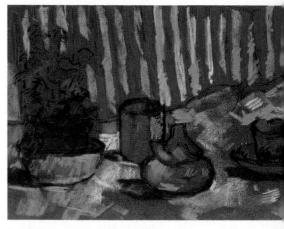

STAGE 2

Method

1 The sanded pastel paper used here will permit almost limitless overworking. However, at this stage, the drawing was made with charcoal in much the same way as with any other surface.

2 The first applications of colour were made with strokes and also by turning the pastel on its side to gain greater coverage. Because of the highly textured and abrasive nature of the paper, finger blending is not that easy. It is also liable to make your fingers sore if you do too much of it.

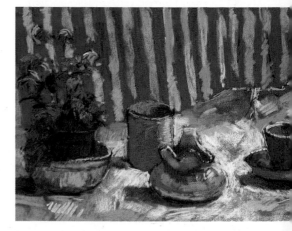

STAGE 3

3 More colour was added to all areas developing the contrasts and establishing a balance throughout. However, it is still very much in the

building up stage and it is not time yet to start refining any one area.

4 By now, sufficient colour had been applied to give overall coverage. The general tone of the pastel had also been made lighter as the original dark colour of the paper seemed to be dragging the overall brightness down.

At this point it was possible to start resolving more particular issues such as refining the drawing of the cyclamen and white milk jug.

5 Finally the pastel comes together. The stripes in the background were brought into balance and various aspects of drawing were tightened up, such as the ellipses. There were many areas which benefited from the highly textured

sanded surface which permitted subtle and close colour gradation without losing its edge.

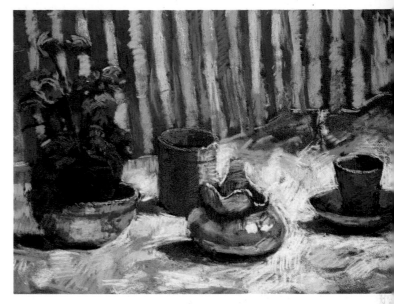

STAGE 4

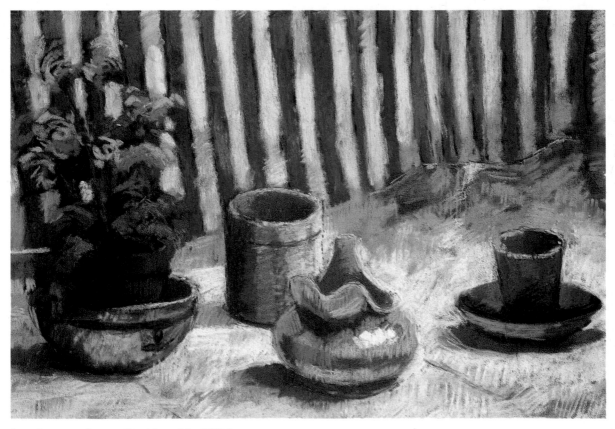

STILL LIFE WITH STRIPES, 25 x 34 cm (10 x 13½ in)

Interiors

Interiors make fine subjects – sunlight streaming through a window, with sharp contrasts, or soft evening light illuminating a bare interior, creating an almost abstract pattern of mid-tones. As a subject, interiors are freely available to all. Everybody lives in an interior of some description so it follows that we all have access to them and in addition some knowledge of the subject – always an advantage. Yet, because we take so much for granted in our living spaces, it can take some rethinking to see these areas as potential subjects for painting, not just something to paint as a last resort but positive painting subjects often with a distinctive quality of light.

LIGHT

The quality of light that exists in an interior is what gives it its character and unique appearance. Any room that faces south will receive direct sunlight throughout the day, unlike an artist's studio which will often face north and have a cool light. Bright sunlight coming through a window will produce distinct areas of strong shadow with plenty of contrast. It will also illuminate certain edges whilst casting other areas of the room into a mass of concentrated tone.

Rooms bathed in a cooler quality of light, without sun, will usually be seen in a more even and saturated light. The advantage here is that it enables you to see a wider range of colours in a subtle variation of gradated tones.

Unusual light
We take ambient lighting very much for granted, whether artificial or daylight, and also the fact that there is sufficient light to be able to see what is being worked on. Occasionally it is exciting to take up the challenge of something more unusual, such as moonlight or candlelight. In these situations there is generally insufficient light to be able to

deal in colour properly so you may have to rely on a good tonal study and sort out the colour later.

Candlelight will illuminate only the very immediate area and everything else will fade into a deep and mysterious gloom. Moonlight can illuminate a room in much the same way as sunlight, though to a lesser degree. The fall of light and resulting shadows will appear in a similar fashion to the sun and if you get stuck it is quite possible to work on the same spot in sunlight. Remember, however, that although this will help you in the direction of the light, you must be sure to make allowances for the much cooler and less powerful light which will reduce the range of colours visible.

Artificial light
If you have to work in artificial light, as we all have to at some time, it is important to try and achieve a balanced effect. Fluorescent tubes on their own give a very flat blue biased light which can affect your colours dramatically. Try to use another source of warmer light in conjunction with it to counter the effect. Daylight-adjusted bulbs are probably the best to work by, although I have also had success with tungsten lights.

One advantage of using artificial light to illuminate your subject is that you can have a great deal of fun organising lighting effects. Spotlights are excellent to use in conjunction with a main light source. If you are painting a portrait, a spotlight aimed at one side of the face will give an interesting network of shadows and depth to your subject.

Whether your subject is a whole room or small corner, you should aim to avoid the overall, flat light which is so often typical of artificial light. It really is worth investing in one or two portable spotlights to enliven your scene.

INTERIOR WITH CHAIR AT LES PLANES

The quality of light that exists in any interior is always unique to the location. In the case of this pastel, the room was in an eighteenth-century French Pyrenean country house. The house was built to be cool so the window area is relatively small. This gave a very particular quality to the way the light entered the room. Somehow everything manages to be so different in a house like this – the furniture, the fabrics and even the panelling on the doors. I was very struck by the way the chair appeared in the stream of light from the window, rather like looking at the light at the end of a tunnel.

There was a point in this pastel where I felt the whole thing was becoming too dark. But if one is to achieve the contrast between inside and outside then the tonal extremes have to be jacked up. In reality the tone seen against the back of the chair would have been darker but as so often happens in this sort of situation the optical effect creates a light area, rather like a halo, around the object seen in space. My colours in this depended quite heavily on cœruleum, blue green and Prussian in a

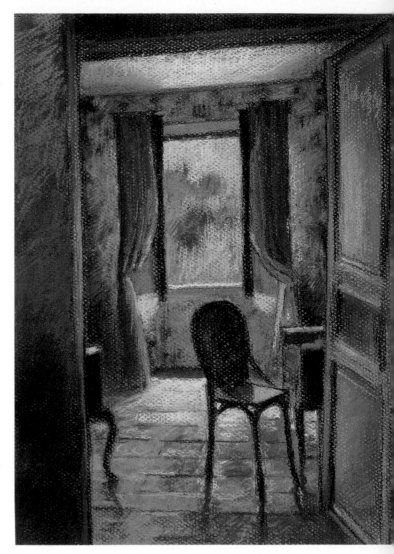

Interior with Chair, Les Planes, 32 x 24 cm (12½ x 9½ in)

range of tints. The other colours were a standard range of ochres and umbers modified with white and charcoal.

BUSY INTERIOR

Restaurants are marvellous places to draw or paint in because they are so full of life and interesting architectural details. Pastel board is ideal in this situation as it keeps quite rigid and eliminates the need for a drawing board. Working in cafés and restaurants is not as difficult as it sounds. Brown's is huge and I used to arrive at opening time and stay for a couple of hours, after which time it became too crowded for my purposes. As long as you are not taking up valuable space, most restaurant and café owners are quite pleased to have an artist making pictures of their establishment. I have spent many happy hours over the years in this way.

To some extent the colours in an interior like this are already harmonised.

Add to this the neutral black and white of the waiter and waitresses' uniforms and a very workable colour scheme is provided.

This pastel was made out of my 'bit box' using quite a small range of colours. In addition to black and white, Vandyke brown and burnt umber were combined with Naples yellow and yellow ochre. The greens were Hooker's and a permanent green. A dash of vermilion was used on the girl's scarf.

Brown's Restaurant, Cambridge, 25 x 33 cm (9½ x 12½ in)

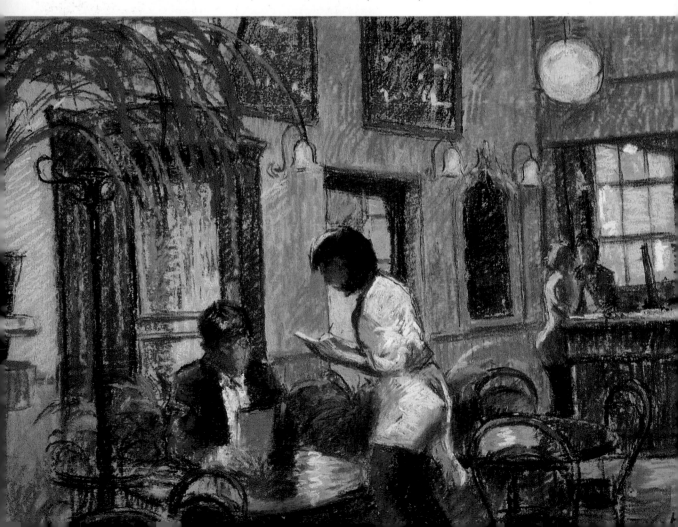

INSIDE AND OUTSIDE

Interior views from the inside through an open window or door can be very taxing because of the extremes of tonal contrast. In fact, this is one area where the artist remains supreme as most cameras cope badly because of their inability to make a light reading that can deal equally well with the dark and light passages. So, as artists we have the distinct advantage of being able to make the necessary adjustments. This generally means looking at the two main areas separately and assessing the values accordingly. This way it is possible to make a picture which has equal focus on both the inside and the outside, without sacrificing either part to the other.

1 I began this pastel with a drawing made with Conté providing plenty of information and guidelines for the subsequent application of colour.

2 The first application of colour seems a little anaemic and unsure but, for the reasons given above, it took a while to get the feel of the contrast between inside and outside.

3 At this stage the character of the light flooding through the open window is established and the balance between the blue sky and the darker interior walls is looking more realistic, especially on the right hand side. Contrasts start to appear on the window frame and balcony woodwork.

4 Now that the balance, so essential to this type of subject, has been established, further development can continue in defining more of the central window and balcony area. Apart from the addition of a palm tree, all the colour in this area has been highlighted

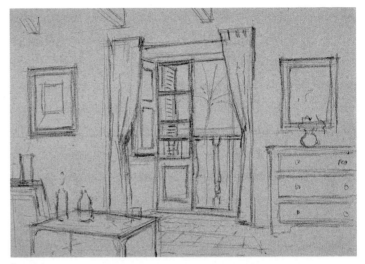

STAGE 1

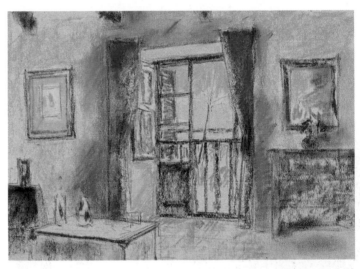

STAGE 2

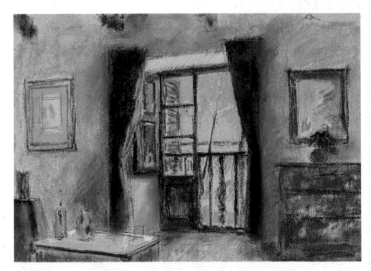

STAGE 3

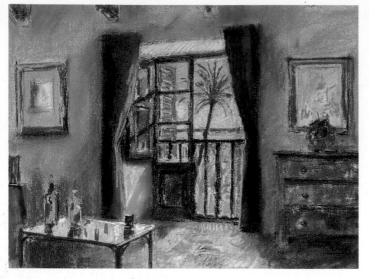

STAGE 4

to create a focus of jewel-like hues in
the centre of the picture. The interior
furniture has also been developed a little
more so that the picture is looking
almost complete.

Finished picture
More definition of interior objects is
made, such as the bottles on the table, the
vases of dried flowers and pictures on the
walls. The contrast of the balcony and its
immediate surroundings is also intensified,
bringing the relationship of the
inside/outside aspect up to its full
potential.

This is not an easy subject to deal with but
a vast amount can be learnt about relative
lights and darks. With particular regard to
pastel, this was an excellent opportunity to
explore the jewel-like quality of the lights
with ready-made tints, against darker and
more sober colouring.

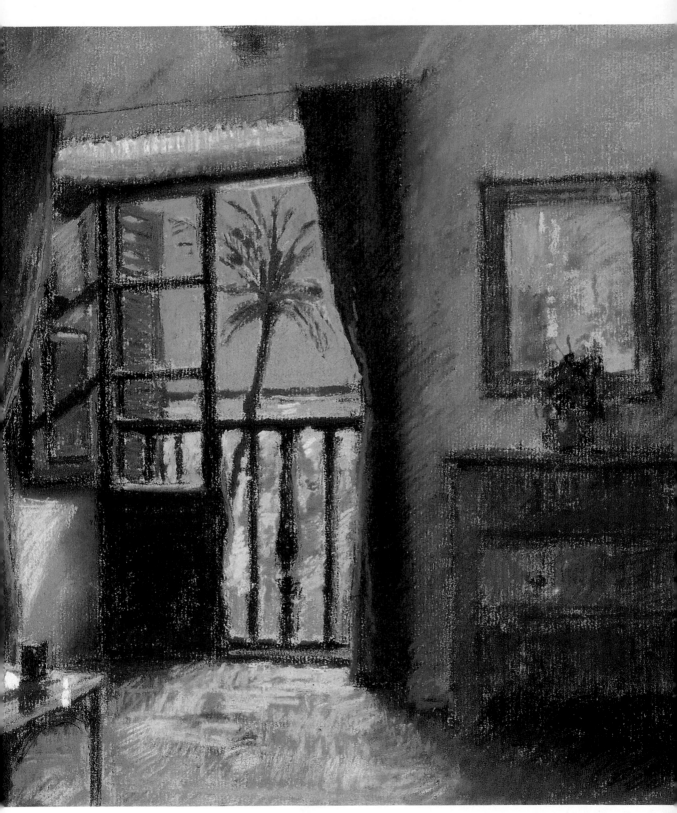

Balcony, Can Xenet, Majorca, 29 x 42 cm, (11½ x 16½ in)

TIP

With a moonlit scene, use a very simplified palette to get your first ideas down because in reality you cannot see that many separate colours anyway. More complex layers of colour can always be added later.

INTERIOR BY MOONLIGHT

Moonlight has mysterious and almost magical quality. It also reduces colour to a bare minimum, creating an almost purely monochromatic scene bathed in a cool silvery light.

Subjects such as moonlight and candlelight cannot always be completed on the spot because of the obvious lack of light, so that the visual memory is called upon much more so than in other subjects. Unfortunately there is no quick or easy remedy to assist here other than to say that the more the visual memory is used and stimulated, the better it becomes.

In this picture, viewed from a room in an old country house in the Pyrenees, the full moon peeped through the window casting a strikingly bright, and almost daytime, light. The red chairs were discernibly red and the strong light, almost like spotlight, shone straight through the somewhat thin and tatty curtains. With such a light the shadows on the floor were superb and created a tremendous atmosphere.

Given such an apparently simple scene, one might have assumed the use of a substantially reduced palette. However, in reality I found myself using as many if not more pastels than usual. The reason for this was that with such large areas of relatively little content, there was a need to keep the colours alive and interesting from a textural point of view.

Method

1 All that needed to be defined here was an indication of where the general masses and light and dark tones should be. The drawing was made with soft charcoal pushed a little with the fingers just to soften the lines.

2 The basic colours were laid down quickly, using the fingers to smudge them into place, so that an idea of the weight of the subject could be established as soon as possible. The colours at this point were a little sharp and garish but they would be modified later on.

3 The grain of the paper started to become saturated as the image became denser. However, the textured side of the Canson paper holds the pigment very well and there was no need for any fixing. Similar delicate touches were

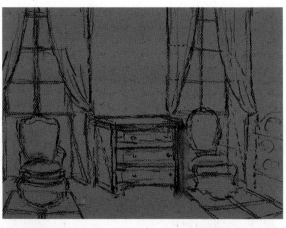

STAGE 1

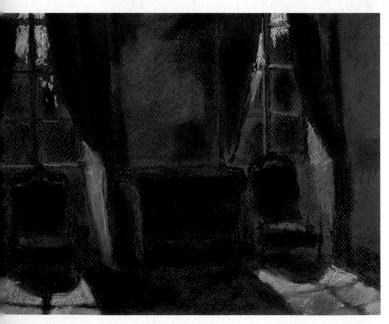

STAGE 2

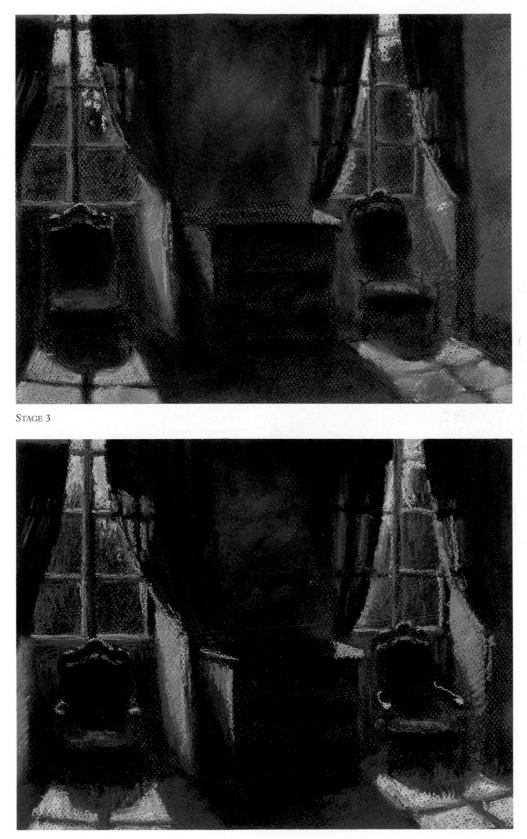

STAGE 3

STAGE 4

now added, such as the light on the curtains, highlights on the chairs and on the edge of the chest of drawers.

4 With the broad aspect of the picture well established (see previous page), more time could be spent on further refining those areas of delicacy and contrast such as the light filtering through the curtains and added highlights on the chairs. The edge of the chest of drawers was also sharpened where it caught the light.

Finished picture

At this point, although the picture was ostensibly finished, it still seemed that the colours were a little too bright for a moonlit room. By using a torchon to take some of the pigment out, such as on the chair arm on the right, and then gently going over some areas with subduing colour, as on the cast light on the floor, the general tempo of the scene was brought more into line with the moonlit effect as it was remembered.

MOONLIGHT, LES PLANES, 23 x 32 cm (9 x 12½ in)

CONCLUSION

It is always difficult, if not impossible with a book of this sort to cover all eventualities. However, if you have found sufficient here to make a start in discovering what pastels have to offer, then the desire to learn more through trial and error should point the way forward.

Having armed yourself with the basic techniques explained in this book, the drive to find your own voice will be full of fun and excitement. Of course, it can be frustrating too because anything that is worth achieving tends not to come too easily and, as with any other endeavour – artistic or otherwise – practice makes perfect.

The 'practice' referred to here is not so much the obvious acquisition of facility, although this is important. It is just as much the desire to learn to see; to retain an inquisitive eye; to vary your approach and to be inspired by everything that goes on around you with all its potential for making an interesting picture. There are no short cuts and even if there were they would be of no value because the joy of what we do is not so much the getting there as the journey itself.

The world is full of artists at various stages along the road, but one thing that is certain is that they would all like to be somewhere farther on. Which is why, once you are hooked, you have a job for life.

SUNSET OVER THE DOGANA, VENICE,
24 x 32 cm (9½ x 12½ in)

LIST OF SUPPLIERS

Tollit and Harvey
Old Meadow Road
Kings Lynn
Norfolk PE30 4LW

3K Project Art
82 The Cut
Waterloo
London SE1 8LW

Daler-Rowney
PO Box 10
Bracknell
Berkshire RG12 8ST

Winsor & Newton
51 Rathbone Place
London W1

Caran d'Ache
Jakar International Ltd
Hillside House
2–6 Friern Park
London N12 9BX

East London Graphics
86–99 Upton Lane
London E7 8LQ

London Graphic
 Centre
16-18 Shelton Street
London WC2

UDO City
69–85 Old Street
London
EC1V 9HX

Cornelissens
105 Great Russell
 Street
London
WC1B 3RY

Artworks
28 Spruce Drive
Paddock Wood
Lightwater
Surrey GU18 5YX

Pullingers Stationers
109 West Street
Farnham
Surrey GU9 7HH

Hearn & Scott
10 Bridge Street
Andover
Hampshire SP10 1BH

R S Frames
4 Broomfield Road
Sunbury-on-Thames
Middlesex TW16 6SW

Broad Canvas
20 Broad Street
Oxford OX1 3AS

Gemini Craft Supplies
14 Shakespeare Street
Newcastle upon Tyne
Tyne & Wear
NE1 6AQ

James Dinsdale Ltd
22–4 King Charles
 Street
Leeds LS1 6LT

Merseyside Framing
 & Arts Ltd
62–4 Wavertree Road
Liverpool L7 1PH

John E Wright & Co
15 Brick Street
Derby DE1 1DU

Everyman
13 Cannon Street
Birmingham G2 5EN

Rod Waspe
11–13 Bank Street
Rugby CV21 2QE

Colemans
84 High Street
Huntingdon
Cambs PE18 6DP

Windsor Gallery
167 London Road
 South
Lowestoft
Suffolk NR33 0DR

Doodles
61 High Street
Newport Pagnell
Bucks MK16 8AT

Framework
63 Pembroke Centre
Cheney Manor
Swindon
Wiltshire SN2 2PQ

Dicketts
6 High Street
Glastonbury
Somerset BA6 9DU

Mair & Son
46 The Strand
Exmouth
Devon EX8 1AL

C J Graphic Supplies
 Ltd
32 Bond Street
Brighton
Sussex BN1 1RQ

Forget-Me-Not
70 Upper James Street
Newport
Isle of Wight P030 1LQ

Elsa Frisher
9 St Peter's Square
Ruthin
Clwyd LL15 1DH

Inkspot
1–2 Upper Clifton
 Street
Cardiff
South Glamorgan
CF2 3JB

Alexander's Art Shop
58 South Clerk Street
Edinburgh EH8 9PS

Burns & Harris
163–165 Overgate
Dundee DD1 1QF

Millers Ltd
11–15 Clarendon Place
St George's Cross
Glasgow G20 7PZ

The EDCO Shop
47–49 Queen Street
Belfast BT1 6HP

INDEX

A
architecture 51, 52, 54, 56, 84
artificial light 15, 24, 82–3

B
blending 12, 15, 18, 38, 52, 61, 79, 88
brushes 19
buildings 43, 48, 50–57

C
candlelight 25, 70, 82, 88
Cassat, Mary 4
chalks 72
charcoal 12, 14, 24, 29, 38, 60, 64, 72, 88
children 25–7, 64–6
clouds 36
colour
 complementary 22, 23
 primary 8, 22
 secondary 22
 tertiary 22
composition 65, 78, 80
Constable, John 36
contrast 24, 37, 38, 44, 48
cross hatching 15, 16, 29, 43, 54, 67, 79

D
Degas, Edgar 4
drawing board 11

E
easel 11
eraser 13, 16

F
feathering 15, 16
figure 66–73
fixative 9, 12, 56, 67
flesh colours 58, 60, 66
flowers 78–9
foliage 40–45

G
glasspaper 10

H
hatching 15, 16, 27, 39, 43, 54, 60, 67, 79
highlights 59, 62, 90

I
Ingres paper 56
interiors 15, 72–3, 74, 82

J
John, Augustus 44

L
landscape 30–36, 40, 66
leaves 40
light
 quality 24, 82
 direction of 72–3, 82
light and dark 85–6
lost and found edges 24, 78

M
materials 6–13
monochrome 23, 25–7
moonlight 82, 88–9

O
oil pastel 6
optical mixing 15, 16, 78, 83
outdoor painting 11, 30, 36–9

P
pad 9
paper
 texture 9, 12
 weight 9
Pastel Society 4
pastels
 box sets 7, 8
 hard and soft 6
pencils, pastel 6
perspective 22, 50
portraits 58–65
proportion 31, 50

R
reflections 20, 46, 47
ripples 20, 46

S
sanded pastel paper 10, 42, 80
sandpaper 17
shadows 24, 25, 43, 44, 56, 62, 68, 79, 82, 88
sketchbook 14, 15, 18, 40, 51, 64, 66
skies 20, 36–9, 52
space and distance 22, 34
still life 74–81
stippling 16
storage box 11
sunset 47
sunshine 44, 56

T
techniques 14–21
texture 10, 15, 63, 79
tones 22, 23, 29, 70
torchon 9, 12, 15, 90
trees 20, 29, 40–45

U
underdrawing 14, 18, 25, 48, 59, 60
underpainting 20, 25, 72

V
vanishing point 50
view
 angle 31, 51, 66
 balance 31, 85
 composition 31, 40, 42, 50, 74–5
 format 31